Painting
ANIMALS

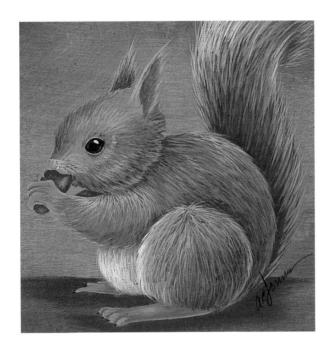

Painting
ANIMALS

DECORATIVE
PAINTERS
LIBRARY

Andy B. Jones

WATSON-GUPTILL PUBLICATIONS/NEW YORK

Senior Editor: Candace Raney
Edited by Joy Aquilino
Designed by Areta Buk
Graphic production by Hector Campbell

First published in 2000 by Watson-Guptill Publications,
a division of BPI Communications, Inc.,
1515 Broadway, New York, N.Y. 10036

Library of Congress Cataloging-in-Publication Data
Jones, Andy.
 Painting Animals / Andy B. Jones
 p. cm. — (Decorative painter's library)
 Includes index.
 ISBN 0-8230-1279-4
 1. Painting—Technique. 2. Animals in art. I. Title. II. Series

 ND1380.J66 2000
 751.45'432—dc21 99-057310

Printed in Hong Kong

First printing, 2000

1 2 3 4 5 6 7 8 9 / 08 07 06 05 04 03 02 01 00

ACKNOWLEDGMENTS

This book is dedicated to my business and creative partner, Phillip Myer. His unending support and constant encouragement have made creating the pieces in this book truly a pleasure. Without his patience and understanding this book would not have been possible.

I would also like to extend special thanks to my editor, Joy Aquilino, who is able to organize and make sense of my ramblings and turn them into great books. Thanks, Joy.

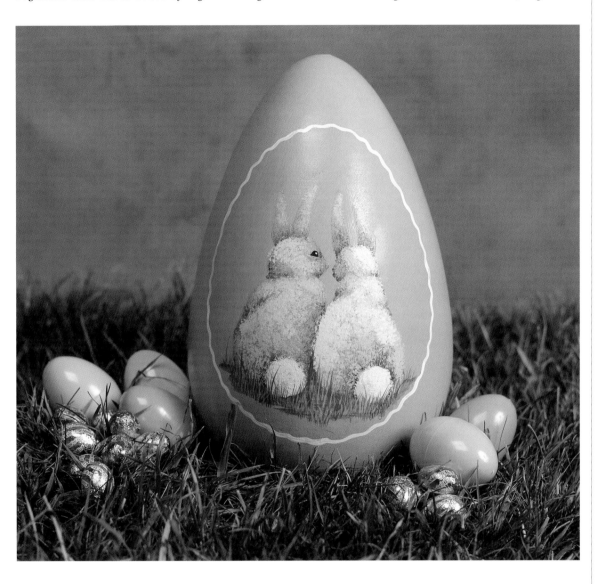

Contents

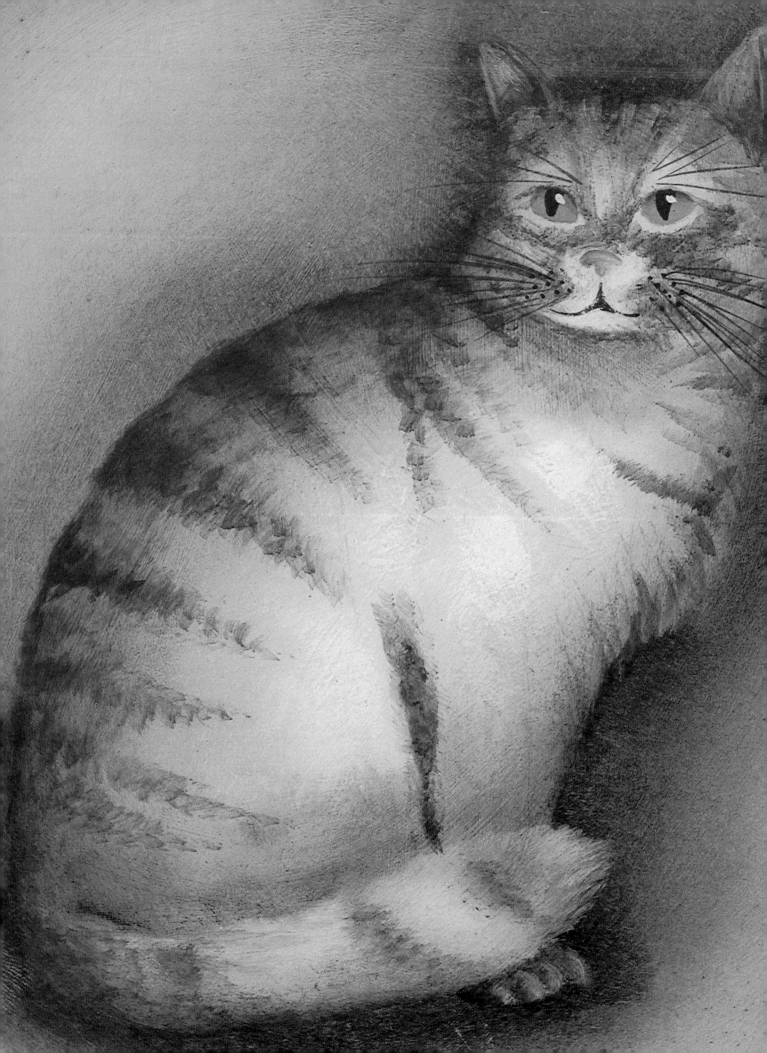

Introduction

Humans have drawn, painted, and sculpted animals for centuries. In fact, some of the earliest works of art—most notably, the cave paintings at Lascaux, France, and Altamira, Spain, which are estimated to be 15,000 years old—masterfully depict bison, deer, and other wild animals. Some scholars believe that these paintings were created to sanctify hunting expeditions or to act out a successful hunt in advance of a real one, while others propose that they were intended to honor and increase the fertility of the animals that gave their lives to sustain the tribe. Regardless of their true purpose, they document that even prehistoric humans had a profound emotional relationship with the animal kingdom.

Although the paintings in this book are in many respects far removed from their prehistoric forebears, they still convey the powerful affinity that people feel for animals. Above all else, artists seek to capture an animal's personality in a painting. By teaching a range of basic painting techniques and including easy-to-paint patterns, *Painting Animals* gives even absolute beginners the skills they need to paint animals with confidence. This book presents a variety of subjects, from intimate companions (dog and cat) to farmyard dwellers (hen, rooster, horse, cow, and pigs) to denizens of the wild (bunnies, fish, squirrel, panda, and giraffe). The painting instructions for each pattern demonstrate a specific technique or combination of techniques, but I encourage readers to open their minds to other possibilities and experiment. Let every project teach you something new and lead you to consider a new approach. You can paint anything you want, as long as you have the desire and a willingness to invest the time and effort needed to master the basic skills. As with anything that's worthwhile,

decorative painting can be learned; once learned, it will give you many enjoyable hours of creative growth and discovery.

THE DECORATIVE PAINTERS LIBRARY

The books in the Decorative Painters Library are designed to fulfill two goals. The first is to instruct beginning painters in the fundamentals of the craft. This essential information, which is covered in depth over three chapters, is then applied to achieve the second goal of the series: to give readers the means to create inspiring projects that feature patterns in a specific subject area. The instructions can be followed exactly as they appear, or adapted to accommodate the artist's personal tastes. A painter can choose a project that corresponds to his or her skill and confidence level by noting the "degree of difficulty" rating:

EASY

MODERATE

CHALLENGING

Whatever your interests and goals as an artist, I hope that this book encourages you to pursue your creative development. If your energies are focused on decorative painting, I urge you to join the Society of Decorative Painters, an international organization with hundreds of chapters across the United States. For more information, contact them at the following address:

SOCIETY OF DECORATIVE PAINTERS
393 North McLean Boulevard
Wichita, Kansas 67203-5968
(316) 269-9300
http://www.decorativepainters.com/

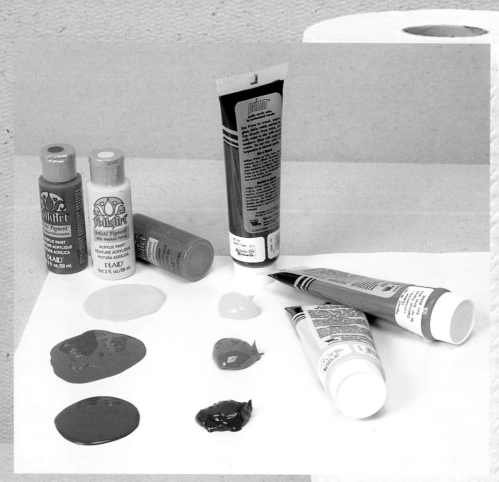

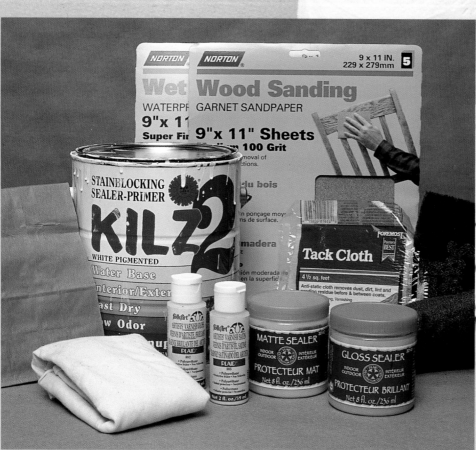

Your Painting Supplies

Working with Acrylic Paints

Originally introduced to the fine-art and crafts markets during the 1950s, acrylic paints quickly gained popularity because of their bright, rich coloration, quick drying time, and ease of clean-up. Almost all of the painting techniques demonstrated in this book were originally done with oil paints, or with a type of modified oil-based paint called japan paint. I learned to paint with oil paints, then began using acrylics when they became popular, and today I use acrylic paints for most of my decorative painting projects.

Acrylic paints come in two varieties: *craft acrylics* and *artists' acrylics*. The colors of craft acrylics, which are labeled with descriptive color names like "barn red," are often created by mixing several pigments. Because the labels on these paints don't usually indicate which pigments were used to make a color, many times mixing two colors together can yield an unpleasant or unexpected result. Despite these limitations, using craft acrylics straight out of the bottle is fine for many applications, such as basecoating a project prior to painting a design.

For painting designs, though, I prefer to use artists' acrylics. Sold in tubes or in 2-ounce plastic bottles, artists' acrylics contain pure pigments, and each color is usually identified by the name of the pigment that was actually used to impart color to the paint, such as burnt umber or naphthol crimson. This information is particularly important when mixing colors, since you always know which pigments you're using as well as the result you're likely to get.

Shown here are the two types of artists' acrylic paints. Squeeze-bottle acrylics *(left)* have a fluid consistency, while tube acrylics *(right)* are more gel-like.

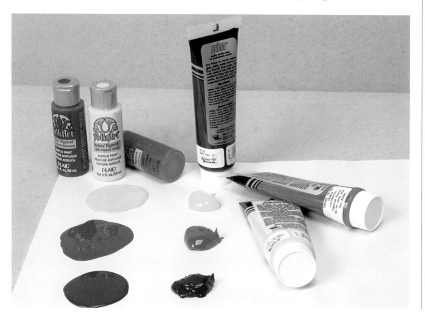

WORKING PROPERTIES

Acrylic paints consist of pigments suspended in a polymer emulsion (a mixture of an acrylic resin binder and water). They dry in only 15 to 30 minutes; once dry, the paint film is waterproof. Acrylics allow an artist to execute a step, then let it dry completely (with no chance of smearing) before proceeding to the next step.

The most important reason for knowing about a paint's *working time*—the amount of time that you have to work with it before it begins to dry—is that it determines which methods you can use to blend colors during the painting process. When they're used straight from the bottle or tube, acrylics dry too rapidly to be applied one at a time and blended on the painting surface; if you attempt to do this you'll be fighting a losing battle with the intrinsic character of the paint. Instead, you must use techniques that take advantage of the paint's rapid drying time. For example, you can use the *drybrush* technique (see page 29), in which one thin layer of color is applied over another layer as soon as the first one is completely dry, so that the colors are blended *optically;* that is, two translucent layers of color combine in the viewer's eye to create a third. You can also blend colors on the brush, then apply the already blended color to the surface and leave it alone to dry. (See "Sideloading" and "Doubleloading," pages 32 and 33.)

Advances in paint technology have resulted in the development of *acrylic mediums*, which are compatible substances that allow artists to manipulate the character of the paint so that it can be used in a variety of ways. In this book, acrylic mediums are used primarily to extend the paint's working time for blending techniques such as working wet-in-wet (page 31), as well as to create beautifully translucent glazes for washes (page 30), texturizing (page 38), staining (page 39), and antiquing (page 42), among other techniques. For information on specific products, see "Acrylic Mediums," page 16.

BUYING PAINTS

When you shop for paints, you don't need to buy every single color that's on the shelf or even in a specific product line. You can either use the materials list that accompanies each project as a shopping list, or you can learn to mix virtually any color using just a few bottles of paint.

(See "Choosing and Using Color," page 26.) If you're new to color mixing, you may want to purchase some of the craft colors that are called for. Shown below is a complete list of colors that were used to paint the patterns in this book.

I use FolkArt Artists' Pigments and FolkArt Acrylic Colors, which are manufactured by Plaid Enterprises and packaged in 2-ounce squeeze bottles. These paints are available at most art supply and craft stores.

PROJECTS PALETTE FOR *PAINTING ANIMALS*

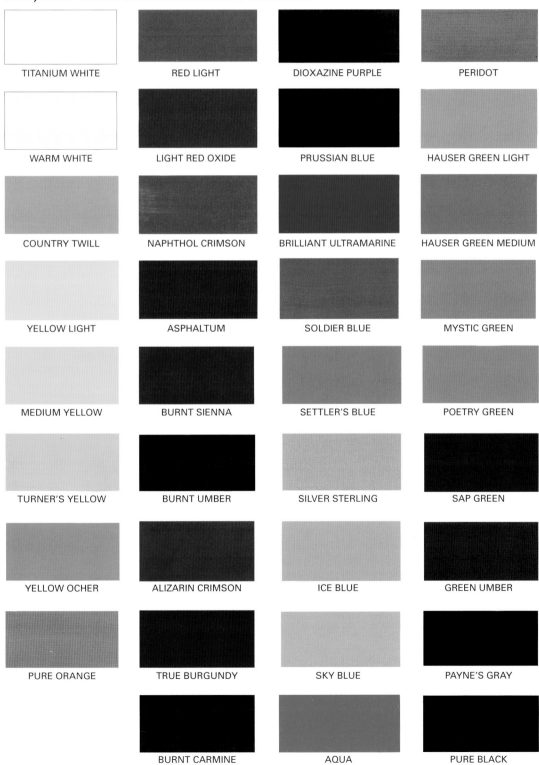

TITANIUM WHITE	RED LIGHT	DIOXAZINE PURPLE	PERIDOT
WARM WHITE	LIGHT RED OXIDE	PRUSSIAN BLUE	HAUSER GREEN LIGHT
COUNTRY TWILL	NAPHTHOL CRIMSON	BRILLIANT ULTRAMARINE	HAUSER GREEN MEDIUM
YELLOW LIGHT	ASPHALTUM	SOLDIER BLUE	MYSTIC GREEN
MEDIUM YELLOW	BURNT SIENNA	SETTLER'S BLUE	POETRY GREEN
TURNER'S YELLOW	BURNT UMBER	SILVER STERLING	SAP GREEN
YELLOW OCHER	ALIZARIN CRIMSON	ICE BLUE	GREEN UMBER
PURE ORANGE	TRUE BURGUNDY	SKY BLUE	PAYNE'S GRAY
	BURNT CARMINE	AQUA	PURE BLACK

Selecting Your Brushes

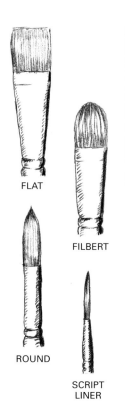

FLAT

FILBERT

ROUND

SCRIPT
LINER

Basic brush shapes.

Without a doubt, brushes are your most important decorative painting tools. You should always use the best brushes that you can afford, as only good-quality brushes will allow you to achieve satisfactory results. Brushes of inferior quality will frustrate you because they won't perform properly. I find that my students' painting problems are often caused by inferior brushes, or by brushes that have been ruined by neglect. If you start with good-quality brushes and maintain them properly, they will perform well for many years.

BRUSH BASICS

HAIRS The word "hairs" is commonly used to refer to the part of the brush that holds and applies paint, though brushes can be made of animal hairs such as sable, squirrel, badger, and boar; synthetic fibers like nylon and polyester; or a combination of the two.

SHAPES The part of the brush in which the hairs are arranged is called the *ferrule*. Typically made of metal, the ferrule also attaches the hairs to the handle. As explained below, the shape of the ferrule determines the shape of the hairs. The basic shapes of brushes used for decorative painting are flat, round, bright, and filbert. As the name suggests, the hairs of *flat* brushes are held in a flattened ferrule, and are all very close to the same length. *Brights* also have same-length hairs, but the hairs are shorter than regular flats. The hairs of *round* brushes are arranged in a cylindrical ferrule and taper to a soft point. *Liners* are small round brushes whose hairs taper to an extremely fine point. *Filberts* are also rounded at the end, but the hairs are held in a flat ferrule.

SIZES The sizes of most of the brushes you'll use for decorative painting are listed in catalogs by number—from 10/0 (the smallest) to 24. A size 2, for example, is about $1/8$ inch; a size 10 is $3/8$ inch. Sizes for larger brushes are often given in inches.

DECORATIVE PAINTING BRUSH KIT
In addition to serving as an all-around basic decorative painting brush kit, the assortment of brushes listed below is used to create the projects in this book. As you gather together a

collection of brushes, buy every other size within a category, then fill in as needed. Of course, if you're going to paint primarily small things, purchase the smaller brushes first. If you're painting large things, don't forget to get a small brush for detail work.

I use brushes manufactured by Silver Brush Limited for my decorative painting. Their brushes are superior in quality and available nationwide. Their Ruby Satin line is made with nylon hairs only, and their Golden Natural series is manufactured with a blend of synthetic filaments and animal hairs. I use the mixed-hair brushes for most of my work. The properties of the natural hair allow the brush to hold moisture and release it evenly, while the synthetic hair gives the brush "spring," or resiliency. Try several of each kind of brush to determine which work best for you.

- *Flats.* Golden Natural Series 2002S, nos. 4, 8, 10, and 12. I use flat brushes for the majority of my decorative painting work because they are so versatile.
- *Round.* Golden Natural Series 2000S, no. 4. The round brush is necessary for creating beautiful brushstrokes, especially large comma strokes. Select a brush with a fine point and a full "belly," or midsection, and make sure there are no stray hairs protruding from the ferrule. You'll have to "break in" your new brush over three or four painting sessions before it will become more responsive to your hand. Note that you'll also need an old, worn round brush for the stippling technique (see page 29), which will ruin a new or well-conditioned brush.
- *Script liner.* Golden Natural Series 2007S, no. 2. Liners come in several different hair lengths; for example, spotters have very short hairs, and script liner, or scroll, brushes have very long hairs. Script liners are designed to hold a lot of paint. When you use a liner brush with short hairs you will find yourself constantly having to refill the brush. The Golden Natural script liner, or scroll, brush can be used for most fine detail work. It has very long hairs and is designed to hold a great deal of paint. If you practice using this versatile brush, you will quickly become comfortable with the long hairs and appreciate its responsiveness.

- *Filberts*. Ruby Satin Series 2503S, nos. 6, 8, and 10. Filberts are useful for highlighting. Because their hairs have rounded corners, they don't leave the conspicuous marks that are sometimes left by flat brushes.
- *Wash brush*. Golden Natural Series 2008S, 3/4 inch. This large flat brush is very useful for applying basecoats (see page 36) and for any other decorative painting application where large areas must be covered with paint.
- *Mop brush*. Golden Natural Series C9090S, 3/4 inch. This very soft brush is designed for very lightly blending and softening paints or glazes, and for softening background antiquing. Do NOT use it to apply paint.
- *Glaze/varnish brush*. Series 9094S, 1 inch. This sturdy brush is far superior to a foam brush for the application of varnish in that it is much less likely to form air bubbles on the project surface. It can also be used to prime and basecoat small and medium-sized projects. Use the 2-inch size for larger projects.
- *Stencil brush (optional)*. Golden Natural Series 1821S, no. 14. The hairs of this stencil brush, which are made from the highest quality hog bristle, are set in a round ferrule and are all the same length. Use this brush by holding its handle upright and sparsely loading only the flat surface of the hairs. Never use a stencil brush if it's wet.

BRUSH CARE AND MAINTENANCE

The correct procedure for cleaning a brush must be mastered from the beginning, and your brushes must be cleaned after every painting session. Brushes will quickly be ruined if you allow paint to dry or harden in the bristles. No matter how skillful a painter you are, your work will suffer if you mistreat your brushes. With proper care and cleaning your brushes will perform as they were designed to, and should last for years.

Use water and a mild soap to clean brushes that have been used with acrylics. Rinse the brushes in cool, running water, working the bristles gently against the palm of your hand. As you rinse the brushes, add a small amount of brush cleaner or conditioner, or a mild liquid vegetable oil soap like Murphy Oil Soap. Continue working the brush in your palm until no more color is released from the brush. Store the brushes bristle up in a glass or jar with nothing pressing on or bending the bristles.

Acrylic paint that has been allowed to dry in a brush can sometimes be removed by cleaning the brush in rubbing alcohol, which acts as a solvent, "melting" the paint so that you can loosen it from the hairs of the brush. Once you've loosened the paint, clean the brush with water and soap as described above. Alcohol is hard on brushes, so use this cleaning method only when absolutely necessary. The best strategy is to never allow paint to dry in your brush!

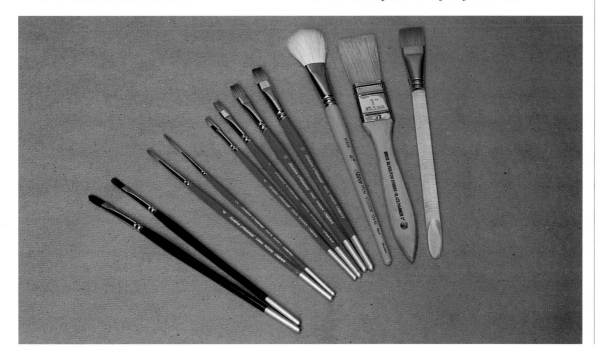

Shown here are the brushes you'll need to complete the projects in this book *(from left to right):* nos. 6 and 8 filberts; a no. 4 round; a no. 2 script liner; nos. 4, 8, 10, and 12 flats; a 3/4-inch mop brush; a 1-inch glaze/varnish brush; and a 3/4-inch wash brush.

Decorative Painting Necessities

In addition to your paints and brushes, you'll need a variety of supplies to create the projects in this book.

BASIC PAINTING SUPPLIES

PALETTES Acrylic painters need two palettes. For mixing color and loading your brushes, you'll need a wax-coated disposable paper palette designed for use with water media. (If you use a palette designed for oil painting, the surface will wrinkle and buckle and make it difficult to paint.) This type of palette is very convenient: Just tear off the used sheet and throw it away at the end of a painting session, or when the sheet is completely covered with paint. Purchase the largest size you can find so that you can use a single sheet for more than one session.

You'll also need a covered palette that will keep your acrylic paints moist. A good choice is the Sta-Wet Palette made by Masterson Industries. For a detailed explanation of how to set up your palettes, see "Getting Started," page 22.

PALETTE KNIFE You'll need a palette knife for mixing paints. Invest in a good-quality one with a long, flexible blade. If you purchase a good palette knife, you'll only have to make the purchase once. Don't buy a plastic palette knife or one with a stiff blade or you won't be able to "feel" the consistency of the paint as you mix it.

WATER CONTAINER You'll need a container of water for rinsing brushes during your painting sessions. You can purchase a container designed for this purpose, or use any sturdy, wide-mouth container that won't tip over easily. The container shown in the photograph below, left, has special slots designed to hold brushes and a ribbed area in the bottom of the well to help remove paint from the hairs.

PAPER TOWELS Always use high-quality paper towels that are soft as well as absorbent. You'll be wiping and blotting your brushes on paper towels often while you work, and rough, coarse ones can cause the hairs to curl or separate.

SOAP FOR CLEANING BRUSHES Use a commercial brush cleaner or a mild vegetable oil soap to clean dirty brushes without leaving any residue. Both can also be used to clean dirty hands.

RUBBING ALCOHOL Alcohol can be used to clean dried paint residue from your brushes. You should always try to remove all the paint from a brush before it has a chance to dry, but if some paint does dry in the brush, dip it into alcohol, then work the hairs in the palm of your hand before cleaning it as described on page 15.

Rubbing alcohol can also be used to flyspeck a wet acrylic or latex basecoat to create a repelled-paint effect. (See "Flyspecking," page 43.)

ACRYLIC MEDIUMS

Two mediums formulated especially for use with acrylic paints are required to complete the projects in this book. These mediums not only make the paints easier to work with, but they also yield some beautiful translucent effects. I use FolkArt acrylic mediums, which are made by Plaid Enterprises.

BLENDING GEL This revolutionary product, which is also called gel retarder, extends working time without thinning the paint's consistency—in other words, without making it watery—an important consideration for blending applications.

Basic painting supplies: paper towels, brush conditioner and Murphy Oil Soap (for cleaning brushes), a water container, a palette knife, and Sta-Wet and disposable wax-coated paper palettes.

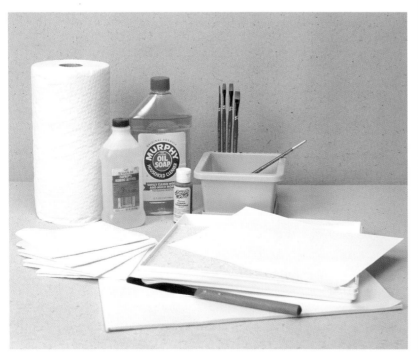

GLAZING MEDIUM In addition to extending the working time of acrylic paint, this product also makes it beautifully translucent. In this book, Glazing Medium is used to create glazes for texturizing (see page 38), staining (page 39), and antiquing (page 42).

SURFACE PREP SUPPLIES

Before you can actually begin painting a design, you'll need to prepare the surface of your project. The following are some standard supplies for preparing wood and metal surfaces.

SANDPAPER Sandpaper is available in hardware stores and home improvement centers. You'll need two grades: medium (#220-grit) for the initial rough sanding, and fine (#400-grit) for smoothing and finishing. Buy a package of each so you have them on hand.

TACK RAG OR CLOTH A tack rag is a piece of cheesecloth that has been treated with resin and varnish. Its extremely sticky surface is used to remove sanding residue, giving finished pieces a smoother, more professional look.

PRIMER Primer is required for some wooden pieces. (See page 36 for details.) If your wooden pieces are small, you can use a spray primer.

SCRUB PAD Use a scrub pad to "sand" a primed wooden surface prior to basecoating.

BASECOAT PAINT To impart color to the surface, you can use craft or artists' acrylics or latex house paints. I enjoy using Durable Colors by Plaid, acrylic paints that are specially formulated to deliver excellent wearing strength. They are available in a wide range of colors, are semigloss in sheen, and can be cleaned up with soap and water.

PAINTER'S TAPE Use this product to mask off areas, as is required in the "hen in a basket" project (see page 54).

BROWN PAPER BAG An unprinted brown paper bag (like the ones at your local grocery store) can be used to smooth a final coat of basepaint or an interim coat of varnish.

COTTON RAGS Soft, lint-free cotton rags, like those made from old T-shirts, are indispensible for wiping off antiquing glazes or stains.

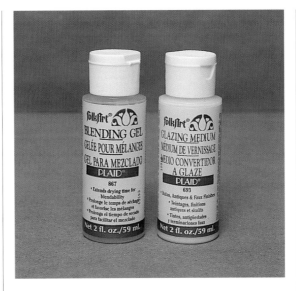

Acrylic mediums: Blending Gel (referred to generically as gel retarder) and Glazing Medium.

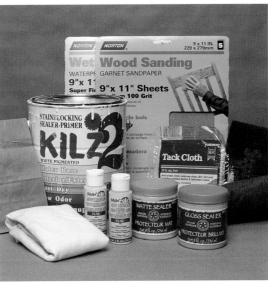

Surface prep supplies: two types of sandpaper, a brown paper bag, wood primer, a tack cloth, a scrub pad, a piece of steel wool, a cotton rag, and brush-on acrylic varnish.

STEEL WOOL In this book, a very fine grade of steel wool (#0000) is used in a special antiquing technique (see page 73). If you use a coarser grade, chances are you'll ruin your piece. It is also used to burnish a copper surface prior to painting (see page 92).

VARNISH I varnish all of my decorative painting projects with a good-quality water-based polyurethane. For small projects I like FolkArt Artists' Varnish, which is sold at many art supply and craft stores. If you plan to varnish many pieces, you can buy gallon-size cans of Varathane at home improvement stores. These two brands are available in a range of sheens, from matte to high gloss. Spray varnish is useful for finishing complex surfaces.

Decorative Painting Necessities

TRACING AND TRANSFERRING SUPPLIES

Once your surface is properly prepped and ready for decorative painting, you'll need to trace a pattern and transfer it to the surface. (See "Tracing, Sizing, and Transferring Patterns," pages 40–41, for detailed instructions.)

TRACING PAPER This transparent paper is specifically designed for tracing. Tracing paper can be purchased in art and craft stores and is sold in several sizes. Buy at least a medium-sized package to avoid having to piece several smaller sheets together. Although tissue paper looks like tracing paper, it isn't a satisfactory substitute because it isn't sturdy enough.

FINE-TIP BLACK MARKER Use a fine-tip marker to trace patterns onto tracing paper. Choose one that contains permanent ink so your tracings won't smear.

TRANSFER PAPER This special paper, which is designed for transferring decorative painting patterns to surfaces, will wash off with water. Do *not* use graphite or typewriter carbon paper, which will cause unsightly messes. Use white transfer paper on dark- to medium-value surfaces and gray transfer paper on light- to medium-value surfaces.

STYLUS Similar in shape to a pen, a stylus is used to trace the lines of a pattern in order to transfer them to a project's surface. Unlike a pencil, a fine-point stylus produces a consistent fine line, so use one whenever you transfer a pattern.

CHALK Purchase a box of ordinary blackboard chalk to transfer simple designs. Do not buy dustless chalk or sewing or tailor's chalk—neither will work—and avoid colored chalk because its pigment might bleed through or otherwise affect the color of your paints.

PENCIL A pencil is invaluable for making marks that will need to be erased, such as the center point of a surface. Do not use a pencil to transfer patterns because it will make increasingly wide lines as its point dulls with use.

SCOTCH TAPE Use this to keep tracings and transfer paper in place.

SPECIAL PROJECT SUPPLIES

Some of the projects in this book require special supplies. Before making any purchases, carefully read the project instructions and materials list to see exactly what you'll need.

WATERPROOF INDIA INK In this book, I use black and brown bottled inks with my crow quill or dip pen. Be sure to use waterproof ink or it will bleed and run when you apply acrylic paint or varnish over it.

CROW QUILL, DIP, OR TECHNICAL PEN Crow quill and dip pens consist of a handle and a nib. Before using either one, gently burn the tip of the nib in a flame to remove the oily protective coating. You'll need a bit of practice before you'll feel comfortable using them. These pens have a tendency to drip or spatter no matter how much experience you have with them, so always "warm up" by testing them out on a

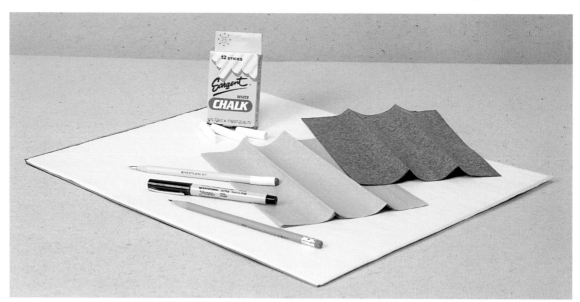

Tracing and transferring supplies: A large pad of tracing paper, chalk, transfer paper in white and gray, a stylus, a fine-tip black marker, and a pencil.

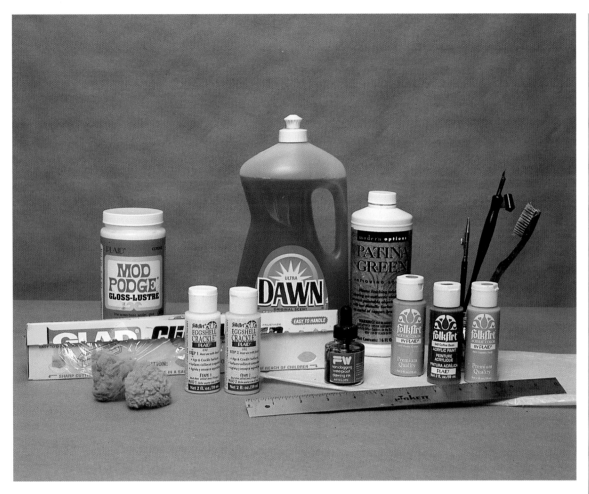

Special project supplies: plastic wrap, a sea sponge, Mod Podge, two-part crackle varnish, dishwashing liquid, a cork-backed metal ruler, waterproof India ink, Modern Options patinizing solution, a dip pen, a ruling pen, an old toothbrush, and a sheet of Ogura rice paper. Also shown: craft acrylics for basecoating (see page 17 for a complete description).

piece of scrap paper before working on your project. If you would rather not work with bottled ink, you can use a technical pen instead. Developed to produce a precisely inked line, technical pens are frequently sold with prefilled ink cartridges.

RULING PEN A ruling pen is a professional draftsman's tool that is used to produce fine lines. To load the pen, first load a flat brush with thinned paint, then scrape the brush across the pen's slotted opening. Draw a straight line by running the pen's point along the edge of a cork-backed metal ruler. You'll need to practice in order to become proficient with this tool. (See "Striping," page 44.)

CORK-BACKED METAL RULER In addition to serving as a straightedge for a ruling pen, a cork-backed ruler can be used to measure surfaces to ensure the proper placement of designs.

OLD TOOTHBRUSH You can use an old toothbrush for *flyspecking*, or applying flecks of paint to a surface to add texture and visual interest. (See "Flyspecking," page 43.)

PLASTIC WRAP Produce a stunning surface treatment by manipulating a coat of wet glaze with a sheet of plastic wrap. (See "Texturizing," page 38.)

DISHWASHING LIQUID This is used to create a special antiquing slurry, or watery mixture, for the Pigs project (see page 70).

PATINIZING SOLUTION Instead of aging the copper surface in the Rooster project naturally (see page 90), I used a sea sponge to apply Modern Options Patina Green, a patinizing solution that produces a beautifully mottled verdigris finish.

CRACKLE VARNISH This product, which is usually applied in two stages, simulates an old varnish surface that has split and cracked.

ORIENTAL HANDMADE PAPER The Horse project (see page 74) uses a sheet of Ogura rice paper as a painting surface.

MOD PODGE This combination glue/varnish is used to simultaneously affix the handmade paper to the Horse project surface and seal it so that it won't absorb paint.

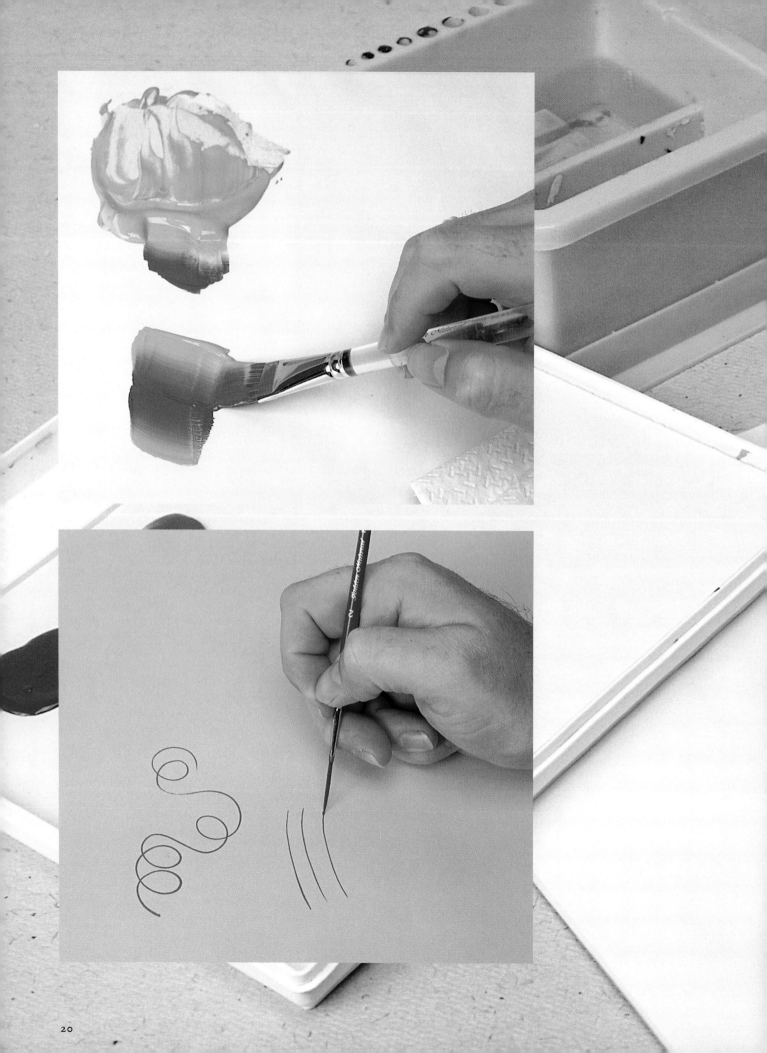

2 Decorative Painting Basics

Getting Started

After you've gathered together the necessary supplies, the next step is to organize your palettes so that you can begin learning how to handle your paints and brushes.

SETTING UP

Over the years, I've developed a routine of working with two palettes: I store my paints in a Sta-Wet palette to keep them moist and workable, and I mix colors and load my brushes on a disposable, wax-coated paper palette. This may sound a bit complicated, but it really fits my working style. If you try my method, I think that the process of painting will be easier for you, which in turn will make you more likely to succeed.

To prepare the Sta-Wet palette for painting, immerse the special palette paper in water. It's best to soak the paper overnight, because if you don't soak it long enough it won't keep the paints moist. Once the paper has been soaked, wet the sponge thoroughly, place it in the plastic tray, then lay the special paper over the wet sponge. Blot the palette paper with a piece of paper towel to remove any standing water, and it's ready for your paints. The palette should remain moist for several hours, although you may need to mist it with water occasionally.

When the palette is covered, the paint can remain usable for days or even weeks.

I almost never load my brush or mix colors on the wet palette because I want to keep the colors I store there clean and pure. When I'm ready to paint, I take the cover off the wet palette, use my palette knife to move some paint to a clean area of my disposable paper palette, then either load my brush or mix my new color with the knife.

THE "RIGHT" CONSISTENCY

The term *consistency* refers to how thick or thin the paint needs to be for a particular painting technique. For most of the techniques that are used in this book, you'll be able to use your paint straight from the bottle or tube, which has a thick, creamy consistency.

To do brushstroke work—the "Essential Brushstrokes" shown on pages 23–25—you'll need to thin the paint by adding a little water to it and mixing them together with a palette knife. While you're mixing, keep the paint from spreading all over the palette by continually pushing it into a single mass. The consistency should be loose: When you pick up some paint on the palette knife, it should slide and drip off the knife with ease. To do linework, which involves creating fine, detailed lines (see page 25), the paint will need to be even thinner—the consistency of thin soup—but not so thin that it hardly contains any color. You don't want to paint your projects with "dirty water"!

Learning to create different paint consistencies requires some patience and practice. The only way to become skilled at handling paints is to actually sit down and begin painting.

LOADING A BRUSH

Stroke the brush into the paint, then apply pressure as you pull some paint away from the puddle, which will cause the hairs to spread. When you release pressure, the hairs will draw together, pulling paint into the brush. Repeat this procedure several times on both sides of the brush until its hairs are completely filled with paint.

I use my palette knife to move paint from my wet palette to my paper palette for mixing colors and loading brushes. To keep the paints on my wet palette clean, I wipe the knife on a paper towel before picking up a new color.

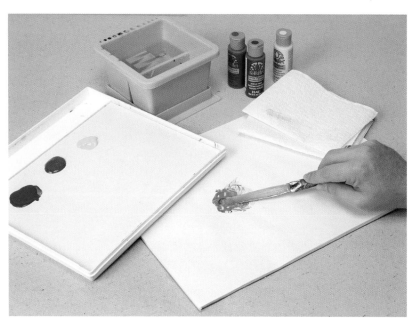

Essential Brushstrokes

Mastering the brushstrokes shown below and on the following pages will help you learn to handle your brushes and paints competently—an accomplishment that is essential to your painting success. With practice, you can master these fundamental skills, but don't let the thought of having to practice lead you to consider skipping this section. If you can't control your brushes, your painting experience will be filled with frustration. Although you won't need to master all of these brushstrokes in order to complete a specific project, giving each one a try can only increase your skill and give you confidence, which in turn will make your painting experience more enjoyable.

COMMA STROKE

This quintessential brushstroke is the foundation of all the strokework you'll need to master. Using basically the same technique, a comma stroke can be painted with either a flat brush or a round brush. Decorative painters should know how to paint both, which require a fluid motion and considerable practice in order to achieve a graceful-looking result.

FLAT BRUSH COMMA STROKE Before you begin, thin the paint with water until it flows effortlessly from the brush (see "The 'Right' Consistency" on the opposite page).

1 Angle the brush toward the corner of your surface, gently touch its hairs to it, then immediately apply pressure. The ferrule (the piece of metal that attaches the hairs to the brush) should *almost* touch the surface.

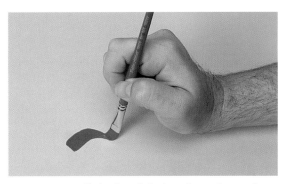

2 As you pull the brush hairs along the surface, gradually release the pressure . . .

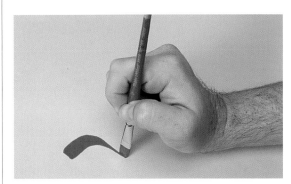

3 . . . while lifting the brush back to its chisel edge. This single, continuous motion will form the brushstroke. Do *not* turn or twist the brush. The brush will make the stroke simply by applying and releasing pressure while dragging it. If you're having trouble, attach a small piece of masking tape to the end of your brush handle. When you paint the stroke, the tape should *not* move—if it does, you're turning the brush.

Essential Brushstrokes

ROUND BRUSH COMMA STROKE To paint a comma stroke with a round brush, load the brush with loose-consistency paint (see "The 'Right' Consistency," page 22). Don't twirl the brush to a fine point after loading it; if the brush is too pointy, it will be difficult to make a nicely shaped head on the stroke.

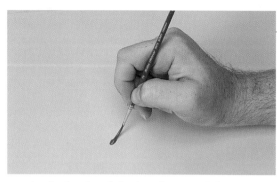

1 Angle the tip of the brush toward the corner of your surface. Touch the brush to the surface and apply pressure to it. The hairs will spread out, forming a nice rounded curve.

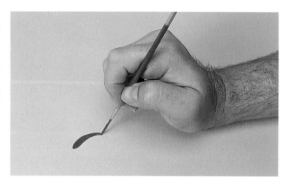

2 Gradually lift the brush as you drag it toward yourself, which will cause the hairs to spring back . . .

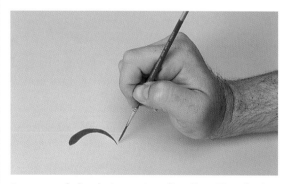

3 . . . and slowly taper to a fine line. You don't need to twist or turn the brush in order to do this. The release of pressure will cause the hairs to form the rest of the stroke.

S STROKE

The S stroke is one of the most graceful brush-strokes in the decorative painter's repertoire. It's similar to the comma stroke in that it requires a single, continuous motion with a gradual application and release of pressure on the brush. You should learn to paint both left- and right-facing S strokes.

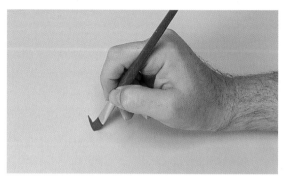

1 Angle a loaded flat brush toward the corner of your surface. Start the stroke by standing the brush on its chisel edge, then slide it toward yourself to create a short, thin line.

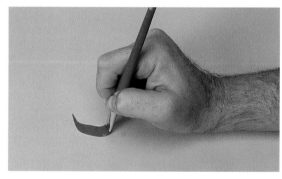

2 Begin to apply pressure as you slide the brush along the surface, gradually increasing pressure until you reach the middle of the stroke. Gradually release the pressure as you continue to slide the brush.

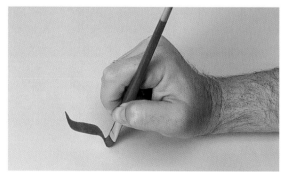

3 End the stroke with the brush on its chisel edge to create another short, thin line. The angle of the lines at the beginning and end of the stroke should be the same.

U STROKE

The procedure for making a U stroke is similar to that for the S stroke (see opposite) except that the shape of the stroke is different.

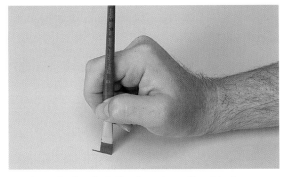

1 Stand a loaded flat brush on its chisel edge. Pull the brush toward yourself to make a fine line . . .

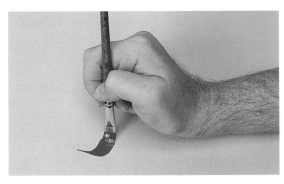

2 . . . then gradually apply pressure to form the wide part of the U. Don't turn the brush, just slide it to the right or left.

3 To complete the stroke, gradually release the pressure on the brush until it's standing on its chisel edge once again.

LINEWORK

Linework is done with a script liner brush using paint that has been thinned to a consistency similar to that of drawing ink so that it flows freely from the brush. If the paint is too thick, either it won't flow from the brush or it will produce thick, unattractive lines. To load the brush, completely fill the hairs with paint (see page 22), then gently twirl them to a fine point as you remove them from the puddle of paint. You need to apply only the slightest pressure to create fine lines and squiggles, and it takes practice to develop the light touch you need.

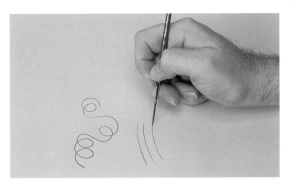

It's fun using one brush to create several different effects.

HANDLE DOTS

Handle dots aren't brushstrokes per se, but they are made with a brush—the handle end! Simply dip the handle into a puddle of paint and touch the handle to the surface to create a perfectly round dot.

To make a series of uniform dots, reload the handle before making each one. To make a series of progressively smaller dots, just load the handle once.

Choosing and Using Color

Once you've practiced the brushstrokes shown on the preceding pages you can think about tackling one of the projects, but before you start painting you should familiarize yourself with some basic color theory.

A *color wheel* makes it easy to understand relationships among colors, which can in turn help an artist create successful mixtures. The standard artist's color wheel includes twelve colors. The three *primary colors*—red, yellow, and blue—are the ones from which all others are mixed, but they can't be mixed from any others. Theoretically, you should be able to make any color using just red, yellow, and blue paint, but the realities of paint chemistry require that we use a few more.

The primary colors lie equidistant from each other around the color wheel. By mixing two primaries you get a *secondary color.* The three secondaries—orange (red + yellow), green (blue + yellow), and violet (red + blue)—lie between the primaries on the wheel. Mix a primary and a secondary and you'll get a *tertiary color,* of which there are six: red-orange, yellow-orange, blue-violet, red-violet, yellow-green, and blue-green.

Colors that lie directly opposite one another are called *complements,* a word derived from the Latin word *complere,* meaning "to complete," which in this case refers to a complete grouping of three primary colors. For example, yellow and violet are complements; yellow is one primary, and violet contains the other two (red and blue), which completes the primary triad. In theory, mixing two complements creates a neutral, grayish color, but the result is often a murky color known informally as "mud."

The following are some tips for creating successful color mixtures:

- Mix colors according to the sequence cited in the instructions. The first color called for is the dominant color in the mixture. For instance, if the instructions call for a mixture of titanium white + Prussian blue, begin with a small puddle of white paint and add tiny amounts of blue until the desired color is reached.
- When creating a mixture, always add color in very small amounts. It's always easy to add color, but very difficult to reverse the effects of adding too much. At that point, it's usually easier to start over again than to fix it.
- So that each paint color will remain pure, get into the habit of wiping your palette knife before using it to pick up a new color or to add more color to a mixture.

In addition to illustrating various mixtures, a color wheel shows that primary colors are the most intense because they are pure; the secondaries and tertiaries are less intense because they are mixtures. Cool colors fall on the blue-green side of the wheel, while warm colors are on the red-orange side.

YELLOW

YELLOW-ORANGE

YELLOW-GREEN

ORANGE

GREEN

RED-ORANGE

BLUE-GREEN

RED

BLUE

RED-VIOLET

BLUE-VIOLET

VIOLET

How Value Works

The term *value* refers to how light or dark a color is. When we describe a color as light yellow or dark blue, we're referring to its value. This concept is most clearly illustrated by a *value scale,* which consists of progressive gradations of gray, ranging from white at one end of the scale to black on the other. Although every step in the scale can be identified as "gray," each is a different value.

Every color can be lightened and darkened to create a range of values. Why is this important? Because by using a range of values in your painting, you can give an object dimension. As you can see below, a circle that's painted with only one value looks flat. But painting the same circle with a range of values can make it look like a three-dimensional sphere.

The most obvious way to change a color's value is to add white or black to it. While this might work well in theory, in practice this can change a color too drastically. Colors can also be lightened and darkened by mixing them with other colors, a strategy that often yields better results. For instance, if you add black to yellow you'll get a greenish hue—an outcome most people wouldn't expect—but if you want dark yellow, you should add a small touch of violet (yellow's complement), or perhaps an earth tone like yellow ocher or raw sienna.

Don't let the occasional uncertainty of color mixing undermine your enthusiasm or your self-confidence. The project instructions will guide you and help you make good choices.

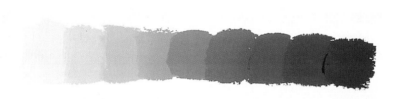

This ten-step value scale illustrates the range of values that can be created by incrementally mixing white and black.

 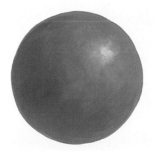

(Far left) If you paint a circle with a single value, it still looks like a circle, but if you paint it with several values, arranging them to create the illusion of form *(near left),* the circle becomes a sphere.

Blending Techniques

Blending techniques are necessary to create the dimensional forms that are characteristic of decorative painting. In order to successfully produce three-dimensional effects, you must be able to paint gradations of color and value so that they gradually—almost imperceptibly—melt one into the next. Before you begin a project, practice the blending techniques that are specified in the instructions, which will make the process of painting the pattern much easier.

BEFORE BLENDING: APPLYING AN UNDERCOAT

An essential decorative painting skill, *undercoating* simply means painting an element with a single solid color. There are two ways to undercoat a motif: by applying the paint smoothly, or by giving it a slight texture.

A smooth application is the more traditional method. To achieve a smooth undercoat, simply load a brush—usually a flat brush—with paint straight from the bottle or tube. Using the brush-strokes demonstrated on pages 23–25 (or variations of these), first apply the paint around the motif's outer edges, then smoothly stroke the paint toward its center until the motif is completely filled in. There shouldn't be a ridge of paint around the motif's edge, and the paint shouldn't have a noticeable texture. If the color or texture of the background is still visible once the paint has dried, apply a second coat, but not before making sure that the first coat is dry.

If the project instructions call for a textured undercoat (the Pigs project on page 70 requires one), start by applying the paint around the motif's edges. As you fill the interior of the motif with color, use the flat surface of the brush to stipple the paint slightly. Since this method of application breaks the surface of the paint, it's very likely that two coats will be needed. Apply the second coat using the same technique, making sure that the first coat is dry before you begin. Avoid creating a noticeable buildup of paint—the goal is simply to produce a slightly irregular texture.

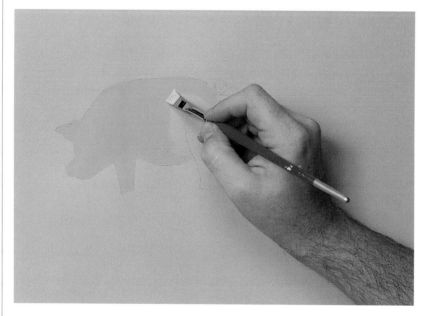

Begin undercoating by applying paint around the motif's outer edges, then smoothly stroke it toward the center.

DRYBRUSH

In the drybrush technique, one sparse, translucent layer of paint is applied over another as soon as it's completely dry, so that the two colors or values merge visually to create a third. This effect is known as *optical blending* because the colors aren't actually blended together but appear to be. Drybrush is particularly suited to creating subtle highlights, which are gradually built up with several thin applications of paint straight from the bottle or tube, each of which is progressively lighter in color and covers a smaller area than the one before. You can begin to drybrush once the undercoat is dry.

Load the brush with just a scant amount of paint in a slightly lighter value than the undercoat, wipe it on a paper towel, then gently skim the hairs across the surface. Let dry, then repeat the process, each time using a slightly lighter color and applying it over a smaller area.

STIPPLING

With the *stippling* technique, paint is applied by dabbing the surface with an old, worn round brush. (A new brush, or one in good condition, will be damaged if it's used for this technique.) Start by loading the brush lightly so that the hairs won't cling together, then tap the brush on a clean area of the wax-coated palette to force the hairs apart, causing them to flare slightly. The brush is now ready for stippling.

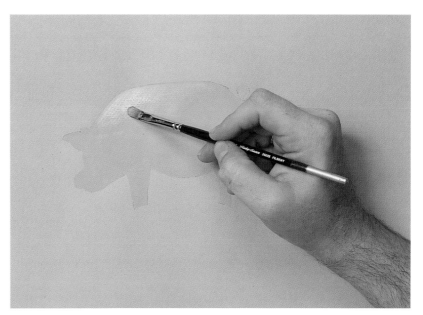

As you apply increasingly lighter values of paint using the drybrush technique, think of the highlight as a pyramid, with each area getting smaller and lighter until you reach the peak, which is usually just a small area of white.

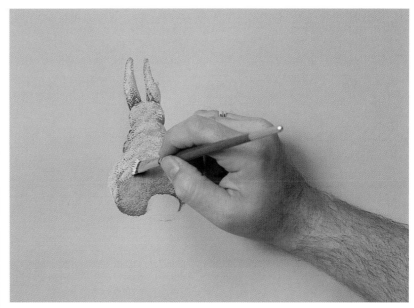

To stipple, hold the brush almost perpendicular to the surface, then tap it wherever you want to create a mottled texture. To create a highlight within a stippled area, let the first layer of stippling dry, then load a small amount of a lighter color on the brush and repeat the procedure. Make sure that the highlight covers a smaller area and leaves at least some of the first layer of stippling visible.

Blending Techniques

APPLYING A WASH

A *wash* is a translucent layer of paint that is used to change and add depth to a color without covering it completely. To create a wash, the paint must be thinned, either with water or gel retarder, until its color is just a light tinge. Paint thinned with water looks more or less the same as paint thinned with gel retarder, except that the retarder-thinned paint maintains its creamy consistency and has a longer working time. When the color is thinned to your liking, load it on a brush, blot the brush on a paper towel, then apply it to the area or motif in smooth strokes. Let the wash dry before proceeding to the next step.

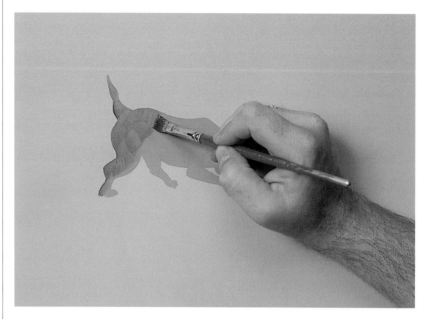

A wash creates depth and dimension . . .

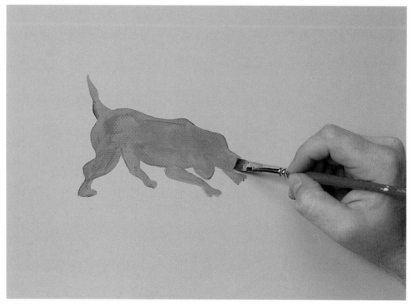

. . . by allowing the underlying color to remain visible.

WORKING WET-IN-WET

Although the process of applying paint in several layers—most typically, undercoating, then shading with a sideloaded brush, then finally drybrushing highlights—can create smooth transitions among several colors or values, working wet-in-wet can create absolutely seamless gradations. The colors are arranged to establish form, with light values applied in areas that should advance within the composition, dark values in those that should recede, and medium values in the rest of the pattern, then lines of demarcation between the values are blended softly.

I Begin by applying a layer of gel retarder to the area, then apply a generous amount of each color or value to the surface. Setting the surface up in this way maximizes the time you have to work with the paints. If you don't apply enough paint, it will begin to "set up"—become sticky and begin to dry—before you've had a chance to blend the colors fully.

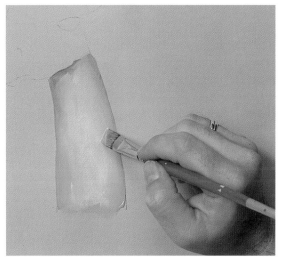

2 Remove excess paint from the brush by wiping it on a paper towel (but *don't* rinse it in water), then use it to very lightly blend colors or values together wherever there's a visible line of demarcation between them. If a color or value begins to migrate to an area where you don't want it (such as dark color in a highlight area), simply wipe the brush on a paper towel, then continue blending. Remember that you can rotate the surface so that you can blend the paints in whatever direction is most comfortable for you.

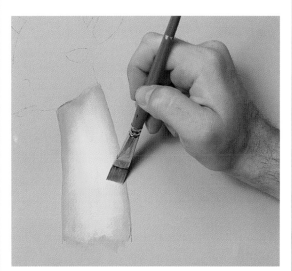

3 When the colors are smoothly gradated but each individual color can still be identified, STOP blending; if you don't, you'll end up with one single color. If you have any problems, let the area dry completely, then reapply the gel retarder and the paints and start over again. Don't try to blend the paint once it's started to dry, or it will begin to lift away from the surface as you work it with the brush.

Blending Techniques

SIDELOADING

Sideloading is an invaluable blending technique that is used to create dimension within a motif. Instead of applying several layers of paint to create a gradual progression of color or value, as is done in the drybrush technique (see page 29), a side-loaded brush is loaded with paint in such a way that its stroke gradually fades from full color on one side to little or no color on the other, an effect that is known as *floated,* or gradated, color.

I Moisten the brush in water or with gel retarder (whichever is specified in the project instructions), then blot it on a paper towel. So that you don't pick up too much color on the brush, slowly stroke one side of the brush next to the puddle of paint, almost as if you're "sneaking" the brush into the paint as you carefully work it into the hairs.

2 To distribute the paint across the brush, move to a clean area of the paper palette and stroke the brush over and over *in one spot*. The color in the stroke should *gradually* fade from full-strength on one side to clear on the other. Be sure to make your strokes only about an inch long.

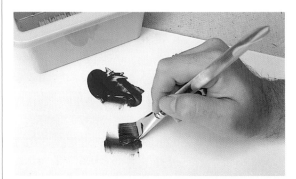

3 Working in the same spot, flip the brush over and repeatedly stroke the loaded side of the brush against the full-strength edge of the stroke.

4 The brush should be properly sideloaded at this point; if it isn't, repeat steps 1 through 3. See the box at left for advice on how to correct and/or avoid other common sideloading problems.

TROUBLESHOOTING

- If you make your strokes longer than an inch (A), or if you make more than one set of strokes, you'll be painting the palette and removing paint from the brush instead of distributing it across the hairs. Keep stroking the brush in the same area, as long as the paint remains moist.
- If the paint beads up on the palette (B), or if the paint extends across the entire width of the brush, then the brush contains too much moisture. Gently blot the brush on a paper towel and try again.
- If the paint seems to drag (C), or if the brush doesn't have enough moisture in it, dip the corner of the more heavily loaded side into water or retarder. This area of the brush will absorb less moisture, giving you more control over how moist the brush is. Be sure to blot the brush on a paper towel any time you add moisture to it.

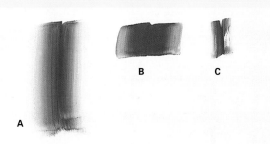

B

C

A

DOUBLELOADING

A variation on sideloading, *doubleloading* loads each side of a brush with a different color or value of paint. In the stroke produced by this technique, the two colors or values on either edge gradually blend to create a third color or value in the center.

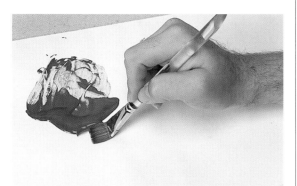

I Moisten the brush in water or with gel retarder (whichever is specified in the project instructions), then blot it on a paper towel. Load one side of the brush with the first color by "sneaking" it into the paint as you stroke it along the edge of the puddle of paint.

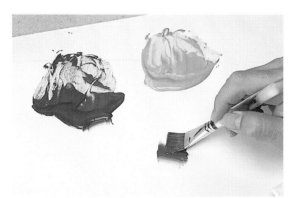

2 To distribute the paint halfway across the brush, stroke it *in one spot* on a clean area of the palette. Don't make your strokes more than about an inch long or the paint will begin to discharge from the brush. Flip the brush over, then stroke the more heavily loaded side against the full-strength edge of the stroke.

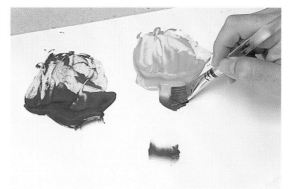

3 Repeat step 1 to load the empty side of the brush with the second color.

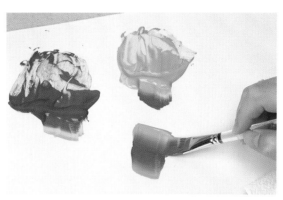

4 Stroke the side of the brush loaded with the first color against the same color on the stroke. Flip the brush and repeat on the other side of the stroke. Pay attention to what you're doing: Don't put the wrong edge of the brush into the wrong color. Load the brush with a little more of each color and continue stroking until the brush is full of paint.

TROUBLESHOOTING

- If the two colors aren't blended enough (A), pick up more paint and continue stroking in the same spot until the two gradually blend together.
- Sometimes the stroke becomes overblended, which muddies the colors on the palette as well as in the brush (B). To correct this, wipe the brush on a paper towel before starting again, but don't clean the brush completely or you'll undo all the good work you've done to fill it with paint.

A

B

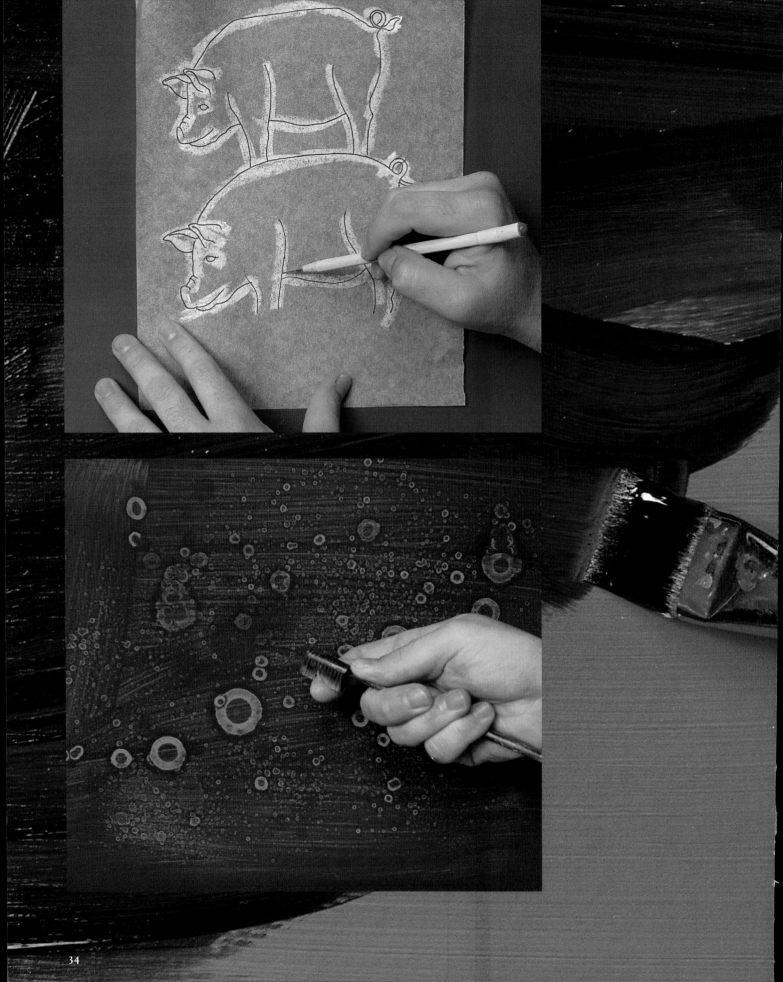

Painting Surface

Preparing Wood

The guidelines below apply to the preparation of new, unfinished wood. If you would like to repaint an already finished piece, you can prime and basecoat it without stripping it first, as long as the wood is in good condition and the finish isn't flaking off or peeling away. If the piece is in poor condition, or if you want to stain it, strip it with a commercial paint and varnish remover following the manufacturer's instructions. When the stripping process is complete, putty and sand the piece as needed, then proceed with the desired surface treatment.

APPLYING WOOD PUTTY

The first step in preparing a wood surface for painting is to fill any nail holes, dents, or imperfections with wood putty. Pick up a small amount of putty with a clean palette knife and apply it to the affected area. Follow the manufacturer's directions with regard to drying times. At this point, the piece is ready for either priming or sanding.

PRIMING

This step generally isn't necessary unless a piece has many knots or you plan to basecoat it with a light color, and should be omitted altogether if you plan to stain it. If you do need to prime a piece, don't spend time sanding it before you prime it because the primer will "raise" the wood grain, or cause it to swell, which requires sanding anyway. Apply one coat of good-quality, white-pigmented primer with a wash brush or a glaze/varnish brush (the size of the piece will guide your choice of brush), then let it dry according to the manufacturer's directions.

SANDING

If you haven't primed your piece, sand it with medium-grade (#220-grit) sandpaper; if you have, sand it with a fine grade (#400 grit) or with a scrub pad. A sanding block—a small block made from rubber or wood to which a piece of sandpaper can be attached—makes the sanding process easier. You only need to sand until the wood feels smooth to the touch.

When you're finished, wipe the entire piece with a tack rag, making sure that even the finest grains of sanding residue have been removed from the surface. Don't skip this step; if you do, the residue can make your basecoat or stain look grainy or flawed.

BASECOATING

You can basecoat wood with any color or brand of acrylic or latex paint that you prefer. The most widely available and convenient choice for small projects are craft acrylics, which are sold in 2-ounce squeeze bottles at most art supply and craft stores.

Use a natural-bristle or mixed-hair wash brush or glaze/varnish brush to apply the paint. These brushes are more responsive and provide better coverage than the foam-type sponge brushes that are currently popular. Dip the hairs about halfway into the paint, then apply the paint to the surface in smooth strokes. Let this coat of paint dry completely, then assess its finish: If it isn't smooth and opaque, sand it lightly with #400-grit sandpaper, wipe it with a tack rag, then apply a second coat. Allow the second coat to dry completely before proceeding with decorative painting or any other surface treatment.

When applying wood putty, smooth out the surface and slightly overfill any concave areas.

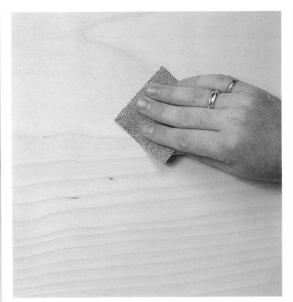

Always sand with the grain, and try to keep your sanding strokes straight and even.

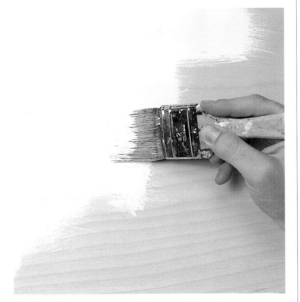

Apply primer to ensure that the grain and any remaining imperfections won't bleed through a light-colored basecoat.

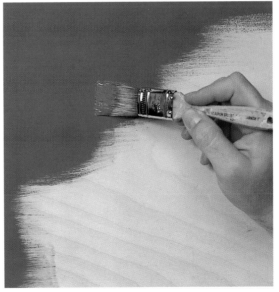

Just as when sanding, always apply the basecoat in the direction of the wood grain.

TEXTURIZING

If you're looking for a surface treatment that's completely different from traditional wood looks, try this simple texturizing technique, which produces a dramatic effect that heightens the visual interest of a basecoated surface. In the demonstration below, I applied a dark burgundy glaze over a red basecoat, but any combination of colors or values can be used.

Before you can texturize your surface, you must basecoat it according to the instructions on page 36. Prepare the glaze by combining equal amounts of Glazing Medium and acrylic paint. Thin the mixture with just a touch of water so that it will brush on the surface a little more easily.

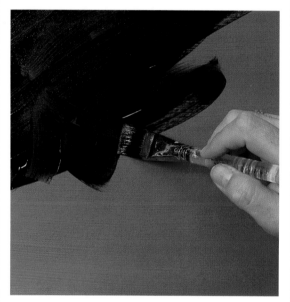

I Apply the glaze generously to the area you want to texturize.

2 While the glaze is wet, lay a piece of plastic wrap over it. Pat the plastic wrap with your hands to make sure it's touching the surface. The wrinkles and creases in the wrap will pull the glaze into an interesting random design.

3 Gently peel off the plastic wrap to reveal the texturized surface. If you like the texture, let it dry, then repeat the procedure on the remaining surfaces. If you don't, simply apply more glaze and try again with a fresh piece of plastic wrap. Make sure the glaze is completely dry before painting a pattern or varnishing the project.

STAINING

A stain is a translucent glaze that is first brushed on, then wiped off, a raw wood surface. This surface treatment is designed to simultaneously soften and enhance the grain pattern of the wood. You can used any color for a stain—I use a green stain in one project, and a dark gray one in another—but brown, gold, and red earth tones, like the burnt umber shown in the demonstration below, are considered traditional stain colors.

To begin, lightly sand the wood with #220-grit sandpaper until smooth, then wipe it with a tack cloth to remove the sanding residue. Prepare the stain by combining equal amounts of Glazing Medium and acrylic paint, mixing it to a nice, creamy consistency.

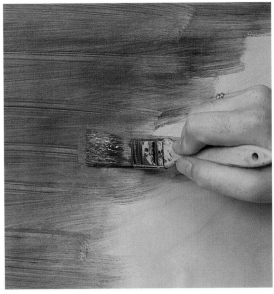

2 While the retarder is wet, apply an ample coat of stain in the direction of the wood grain.

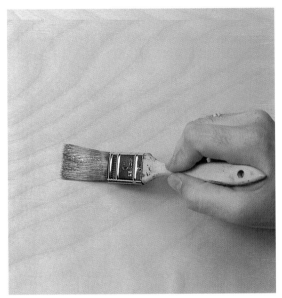

1 Working on one area or surface at a time, apply a generous coat of gel retarder to maximize the stain's working time.

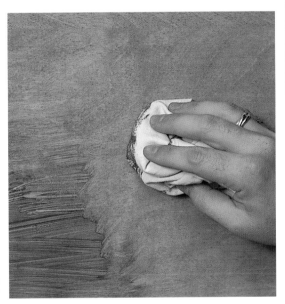

3 Again working with the grain, wipe away the excess color with a soft, lint-free rag. Repeat the procedure on the remaining surfaces, then allow the stain to dry completely (overnight is best). Buff the surface with an unprinted brown paper bag to smooth any grain that was raised. The surface is now ready for painting a pattern or varnishing.

Tracing, Sizing, and Transferring Patterns

The decorative painting patterns at the back of this book are provided for your use and enjoyment. You may use them as is, simplify them by eliminating elements, or embellish them by adding elements from others, or creating your own. Working with an accurately traced, sized, and transferred pattern will make your decorative painting experience more pleasant.

TRACING AND SIZING

Place a sheet of tracing paper over the pattern and carefully outline its contours with a fine-tip black marker. If the traced pattern fits the painting surface, you can simply transfer it using one of the two methods described on the opposite page. If you need to adjust the size of the pattern to fit the painting surface, you can enlarge or reduce the tracing on a photocopier. To determine the correct percentage of enlargement or reduction, use a *proportional scale,* which consists of two concentric discs whose circumferences are printed with a series of measurements. In one of the disks is a window that, when turned, reveals a sequence of percentages. Simply measure the traced pattern's height or width, then figure out what that dimension should be in order for the pattern to fit on the surface. When you line up these two numbers on the disks, the correct percentage of enlargement or reduction will appear in the window.

I use two transfer techniques: the transfer paper method and the chalk transfer method. Either method can be used with any pattern, but the chalk transfer method is better suited to stroke designs and designs that are relatively simple. Also, chalk transfers dissolve more readily when paint is applied, and can't be seen through the paint even when they don't.

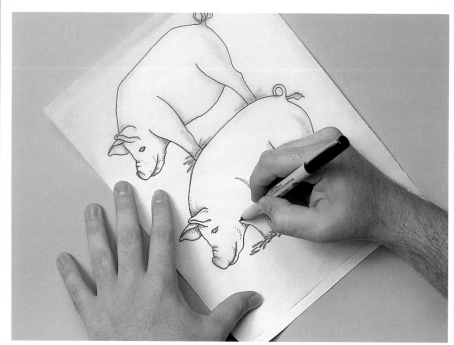

You don't need to trace lines that indicate secondary details like shading, but be sure that you've traced all of the essential lines before removing the tracing paper from the pattern.

TRANSFER METHOD 1: TRANSFER PAPER

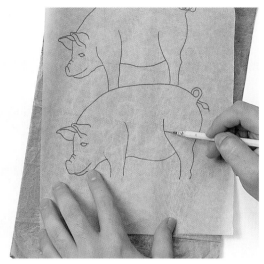

1 Position the correctly sized pattern on the prepared surface. Tape it in place if you think it might slip, but don't affix the tape with much pressure—use just enough to hold the design in place. Slip a piece of transfer paper under the pattern, make a test mark with the stylus, then lift the pattern and the transfer paper to make sure that the right side of the transfer paper is against the surface. (This is an important habit to cultivate, since transferring a pattern to the back of itself is a frustrating waste of time.)

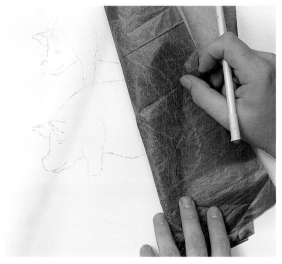

2 Carefully trace all of the pattern lines with the stylus, periodically lifting both the pattern and the transfer paper to see whether you've missed any. One caveat: Don't press hard or you might dent or groove the surface. When you're done, simply remove both sheets and you're ready to paint.

TRANSFER METHOD 2: CHALK TRACING

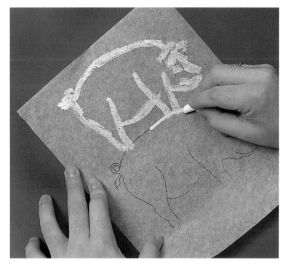

1 Turn the correctly sized pattern face down and carefully trace its lines with a piece of chalk. Do *not* scribble all over the back of the pattern. Gently shake the pattern (but not near the prepared surface) to remove excess chalk.

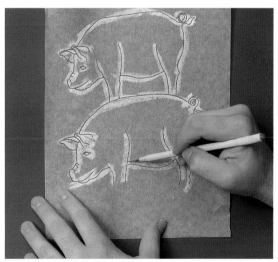

2 Position the pattern chalk side down on the prepared surface, taping it in place if necessary. Use a stylus to trace over the lines. Periodically lift the pattern to make sure you've transferred all of its lines, and that the transferred image is clear.

Antiquing

An antiquing glaze—a layer of color applied, then partially removed, to create a patina of age—can add a wonderful, rich look to designs painted on wood. You can apply an antiquing glaze over a basecoat prior to painting a design, or over a completed design.

Before you can begin antiquing, you must create the glaze. Mix equal amounts of paint and Glazing Medium with a palette knife until they are thoroughly combined, and the consistency of the mixture is similar to thick soup. To extend the glaze's working time, add an amount of gel retarder equal to the entire volume of the mixture.

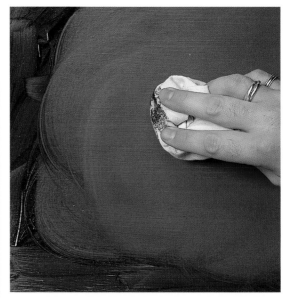

2 While the glaze is still wet, use a soft cotton rag to wipe it away from the center of the surface, working in a circular motion from the center outward to create an attractive highlighted area.

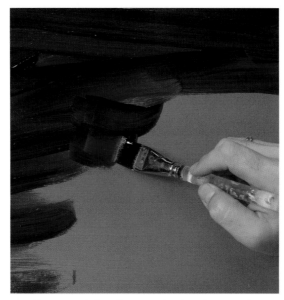

I Use a wash brush to apply the glaze to the surface in a random manner. Be sure to completely cover the area you want to antique.

3 To complete the process, use a mop brush to soften and refine the glaze that remains on the surface. Holding the brush so that the bristles just graze the surface, create a subtle gradation from light (in the center) to dark (at the edges of the surface) and eliminate any obvious marks left by the wash brush or rag in steps 1 and 2.

Flyspecking

Flyspecking creates visual interest by spattering a surface with color or visual texture. A surface can be flyspecked with either paint or alcohol, and an old toothbrush is the requisite applicator for both. Simply dip the bristles into thinned paint or alcohol, point them toward the surface, then run your thumb or finger over them, *toward yourself*. (If you push the bristles away from yourself, you'll flyspeck yourself as they snap back into place.)

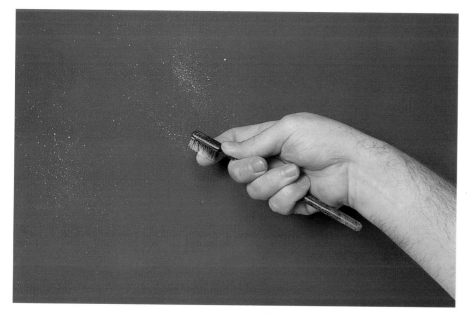

When you flyspeck with paint, you add color to the surface. Thin the paint with water to an inklike consistency so that it spatters more easily. Avoid loading the toothbrush too heavily, as this could cause the paint to blob or drip.

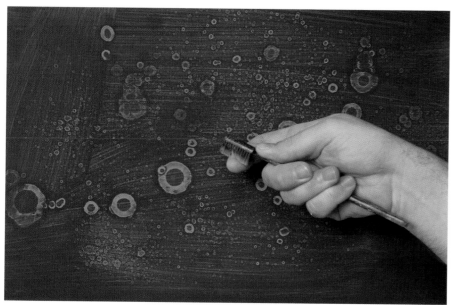

When you flyspeck with alcohol, you repel the color that's already on the surface so that spots of the underlying color will show through, creating an organic pattern. Always make sure that the painted surface is still wet. If the paint has begun to dry, you won't get a reaction.

Striping

Striping—using a ruling pen and a raised straight-edge to create straight, even lines—is an invaluable technique, as it is extremely difficult even for experienced painters (myself included) to paint consistent, accurate lines by hand. Although it is possible to use a fine-point pen or marker for this purpose, a ruling pen can be filled with any color of paint, so that decorative lines will always coordinate with the project's established palette.

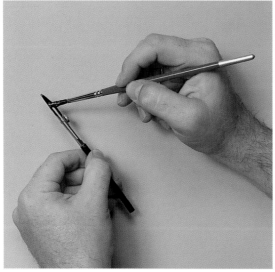

I Adjust the position of the turnscrew to determine the width of the line. Thin the paint with a little water to a soupy consistency, mixing it thoroughly to dissolve any lumps or blobs. Pick up a little of the thinned paint on a flat or round brush, hold the pen so that the slot is facing up, then gently rake the brush across its slotted opening. If the paint is the right consistency, it won't drip out. Wipe off any paint on the outside of the pen with a paper towel.

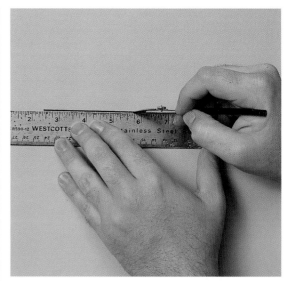

2 Test the consistency of the paint on scrap paper before striping your prepared surface. Set the flat side of the pen against a cork-backed ruler or other raised straightedge so that the turnscrew is facing away from it. Hold the pen at a 45-degree angle to the surface, then gently pull it along the ruler.

3 If the line is accurate and uniform, you can begin striping your prepared surface. If the consistency of the paint is too thin (so that it blobs when you touch the pen to the surface) or too thick (so that it won't flow out of the pen), remix the paint, rinse out and refill the pen, then try again. If a blob forms as you start or stop a line, use a clean, wet brush to remove it. If you need to refill the pen to finish a line, simply overlap the completed line by about 2 inches when you continue.

Crackle Finish

A crackle finish adds a lovely antique appearance to a painted surface by simulating the effects of age on a transparent coat of varnish. I use a two-part water-based crackle varnish product that can be applied either to a specific area or to an entire piece. The first part of the varnish dries more slowly than the second, so it creates cracks in the second part as it continues to cure. The crackle effect is subtle, so I accentuate it with a translucent antiquing glaze. Although the instructions below apply to many brands of crackle varnish, you should follow the manufacturer's instructions for the product that you purchase.

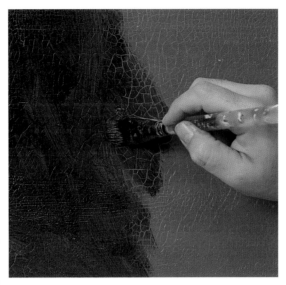

2 Prepare the antiquing glaze by mixing equal parts acrylic paint and Glazing Medium. Brush the glaze vigorously onto the surface to force it down into the cracks.

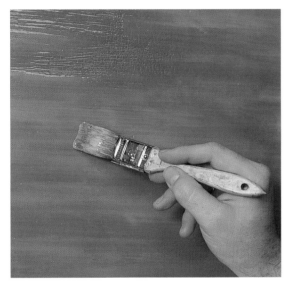

1 Apply a generous coat of the first part of the finish, then let it dry. Repeat with the second part of the finish. The cracks will form as the second part dries, but they won't be too evident unless you inspect the surface closely.

3 While the glaze is still wet, wipe it back with a soft, lint-free rag. The glaze will remain in the cracks, emphasizing the crackle pattern. Allow the glaze to dry, then protect it with a coat of varnish.

Varnishing

The procedure for varnishing is fairly simple, but you must use the proper tools to achieve satisfactory results. Before you begin, make sure that your painting is sufficiently dry. If you're working with acrylic paints, you should wait at least 24 hours after completing the project before varnishing.

APPLYING BRUSH-ON VARNISH

Use a top-quality natural-bristle brush to apply brush-on varnish. A glaze/varnish brush is an excellent choice for this task, as it holds plenty of varnish and releases it in a controlled and even manner. Never apply varnish with a foam brush, which will leave bubbles on the surface—something you definitely want to avoid.

Using the right kind of brush is essential, but its care is important too. I recommend that you purchase a new glaze/varnish brush and set it aside for varnishing only. In fact, I labeled the handle of one of my glaze/varnish brushes so there would never be any question as to which one should be used for varnishing. Why earmark a brush exclusively for varnishing? The answer is simple: If you use a brush to apply paint, traces of paint may remain in the hairs even after it has

been cleaned. Good-quality water-based acrylic polyurethanes, like the FolkArt and Varathane brands I use, contain chemicals that can loosen and soften this residue, which then may be transferred to the surface or leave unsightly streaks of color in the varnish. Wash your varnish brush immediately after applying each coat to prevent a buildup of varnish in the hairs.

Before you begin applying it, stir the varnish thoroughly until none of the cloudy "stuff" (dulling agents) is left in the bottom of the container. (Never shake a can of varnish, as shaking produces bubbles.) If you don't distribute the dulling agents throughout the varnish by stirring it, it will become increasingly dull as you use up the can, and will eventually cloud your finish.

Dip the brush into the varnish, then even out the load on the hairs by scraping them against the container's inner rim. This is done to avoid either "flooding" the surface with varnish or applying so little that you have to scrub it with the brush. Apply the varnish smoothly in a single direction. Let the first coat dry, then repeat the process to apply two more. Three coats should provide adequate protection for your work.

When applying brush-on varnish, flow it on the surface in a uniform layer, working the brush in one direction. Apply a total of three coats, letting each coat dry before applying the next.

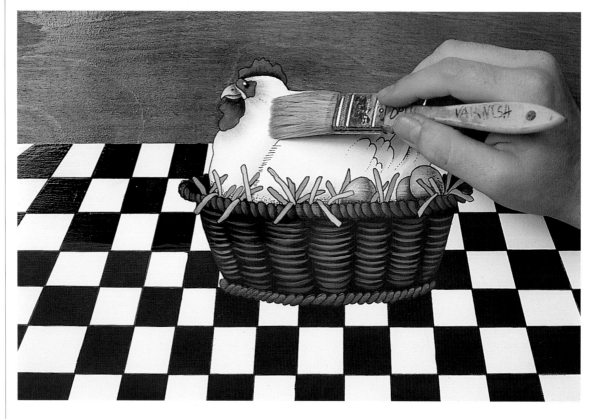

APPLYING SPRAY VARNISH

When finishing an intricately cut or carved wooden or metal piece, acrylic spray varnish provides a solution to the problem of applying an even coat to every nook and cranny. Spray varnish comes in a range of sheens, from gloss to matte. Whatever brand or sheen you use, read and follow the manufacturer's directions carefully.

The fumes and mists that are by-products of spray varnish can be dangerous if your work area isn't properly ventilated—the rooms in most homes aren't designed for this task—so set up outdoors on a balmy but not breezy day. Leave the piece and the spray in your work area for a few hours to bring them to the same temperature, which will help ensure adhesion. Apply a light coat of varnish, holding the can at least 8 inches, but no more than 10 inches, from the surface, moving it with a sweeping back-and-forth motion. As with brush-on varnish, it's best to apply three or four light coats rather than one or two heavy ones.

If you hold a can of spray varnish closer than 8 inches from the surface, the solvent in the varnish may reactivate the paint; if you hold it farther than 10 inches away, some of the varnish may dry before it can even make contact with the surface.

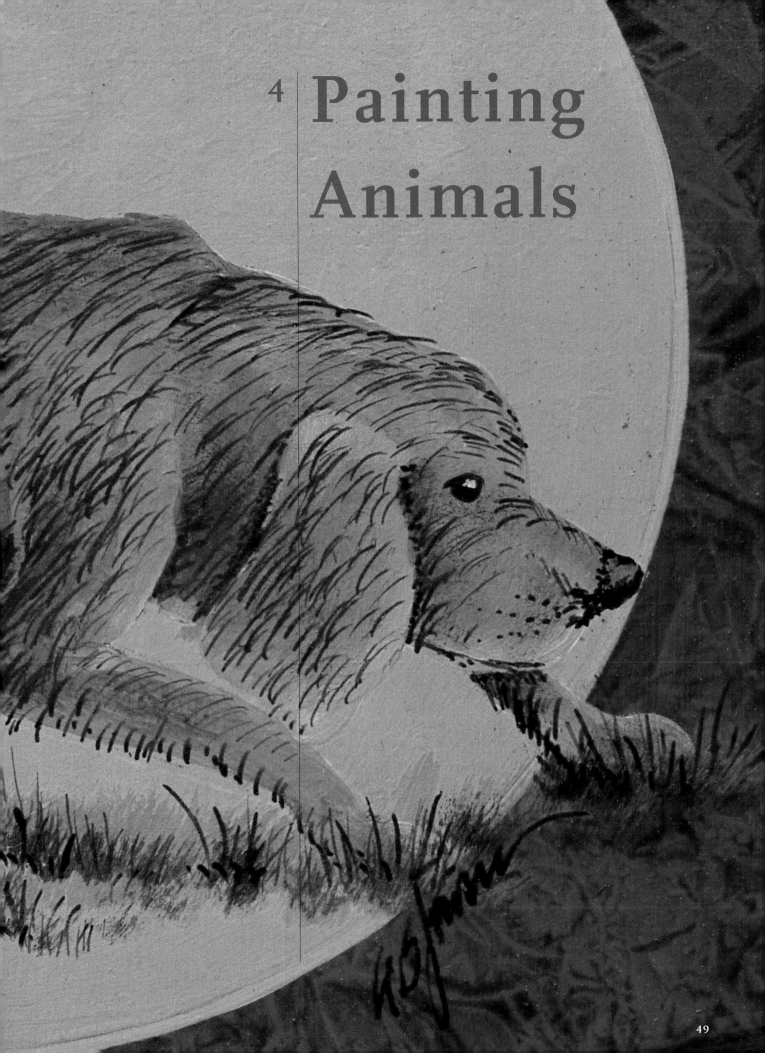

4 | Painting Animals

Bunnies

Degree of Difficulty

Despite the fact that they can eat an entire garden in a single afternoon—just ask Mr. McGregor!—sweet, gentle bunnies have universal appeal, making them popular subjects for painters everywhere. The bunnies in this project are painted on a large wooden egg, a perfect decoration for the Easter season. (To create keepsake Easter eggs, just reduce the pattern and transfer it to real eggs.) Adorn the lid of a box or a framed panel with these bunnies to create a wonderful gift for a baby born in spring.

WHAT YOU'LL NEED

Pattern
Page 100

Project
Wooden egg from Robinson's Woods *(see page 111 for ordering information)*

Supplies

SURFACE PREP
Primer
#400-grit sandpaper
Tack rag
Paints for basecoating *(acrylic or latex):* spring rose *(dull, medium-value pink)* and sky blue *(bright, light-value blue)*

TRACING AND TRANSFERRING
Tracing paper
Fine-tip black marker
White transfer paper
Stylus

ARTISTS' ACRYLICS
Titanium white
Warm white
Burnt umber
Hauser green medium
Hauser green light

CRAFT ACRYLICS
Country twill *(light, dull creamy beige)*

ACRYLIC MEDIUMS
Gel retarder

BRUSHES
Wash brush: 3/4-inch
Flats: nos. 8 and 10
Old worn round brush *(for stippling—don't use a new or good brush for this technique)*
Script liner: no. 2
Glaze/varnish brush: 1-inch

BASIC PAINTING SUPPLIES
Water container
Palette knife
Sta-Wet palette
Wax-coated paper palette
Paper towels

FINISHING
Brush-on satin-sheen acrylic varnish

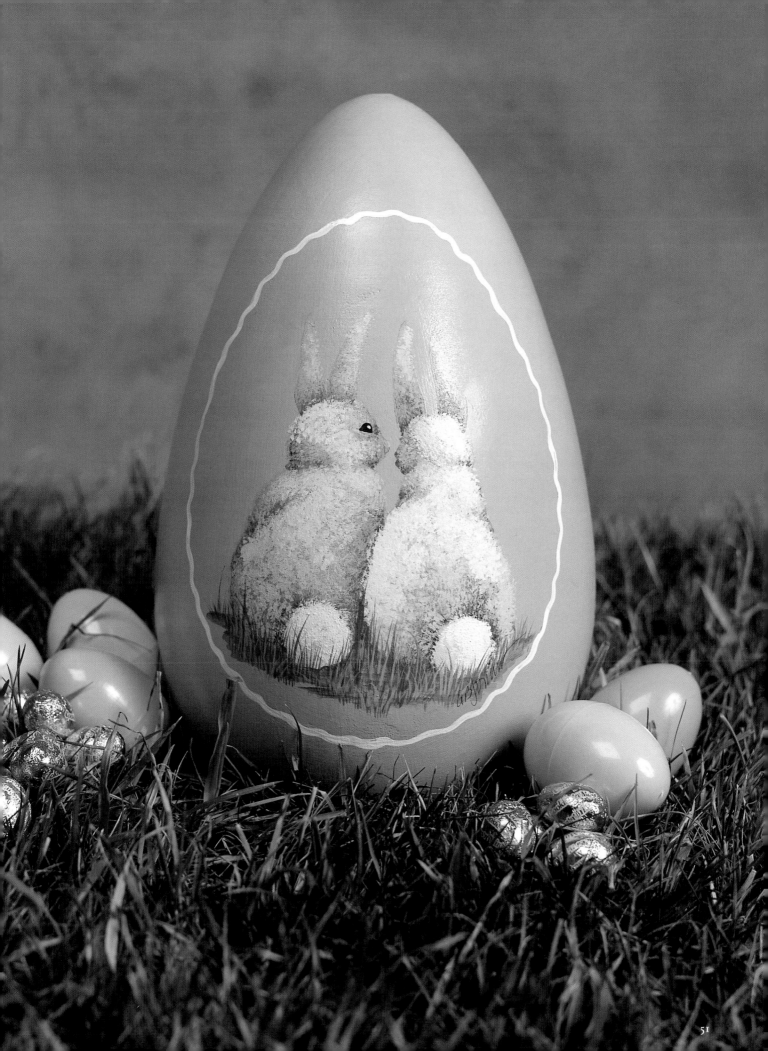

Bunnies

GETTING READY

Prime, sand, tack, and basecoat the egg according to the instructions on page 36, using the wash brush to apply the spring rose paint. Let dry. Sand and tack the surface, then apply a second coat to ensure opaque coverage.

Trace and transfer the oval shape that surrounds the bunnies to the egg. (Do not transfer the wavy stripe, which will be added in step 6.) The egg's curved surface will make this difficult to do. When you've succeeded, use the wash brush to paint the oval with sky blue. If necessary, correct the shape as you paint it. Let the first coat dry, then apply a second. Once the oval is dry, trace the bunnies' outlines, then transfer them to the surface. (Details like shading and grass will be painted in later.)

I Use the no. 10 flat to undercoat the bunnies' bodies with two coats of country twill, letting the first dry before applying the second. The undercoat serves as the local color—the medium value—on the bunnies.

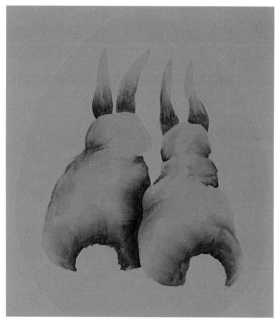

2 Moisten the no. 10 flat with gel retarder, then sideload it with burnt umber. Shade the base of the ears and around the tails, patting the color out into the undercoat to avoid creating a harsh line of demarcation between shaded and unshaded areas. When shading the bunnies' bodies, position the burnt umber side of the brush against their outer contours, again patting the color in toward the center to soften the application of color. Use this opportunity to create "folds" in the fur at the indentations in the bunnies' outlines. Let dry.

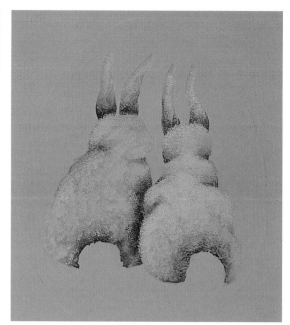

3 Following the instructions on page 29, stipple the bunnies with the old round brush to create the appearance of fur. Begin by stippling country twill all over both bunnies. This layer of stippling softens the shading that was applied in step 2 but won't be visible on unshaded areas. Let dry.

Lighten some country twill with a bit of warm white, then stipple it along the right side of each ear, at the top of the bunnies' heads, down the center of their backs, and in any plump areas—that is, over most of their bodies, but not so heavily that you can no longer see the undercoat or the shading. Let dry.

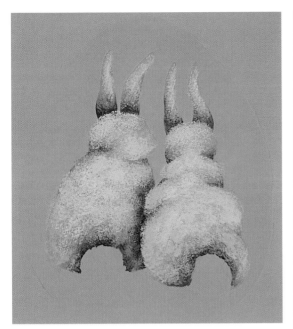

4 Lighten the country twill/warm white mixture with a little more warm white, then stipple the bunnies once more, this time concentrating the application on the bunnies' plumpest areas. Let dry, then stipple warm white on the peaks of the highlights. Let dry.

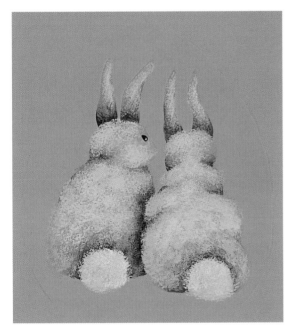

5 Lighten the country twill/warm white mixture once more, then use it to undercoat the tails with the no. 8 flat. Let dry, then stipple warm white over both tails. Once the first layer of stippling has dried, highlight the tops of both tails by stippling them with a little titanium white. Let dry.

Use the script liner to undercoat the bunny's eye with burnt umber, let it dry, then highlight it with titanium white.

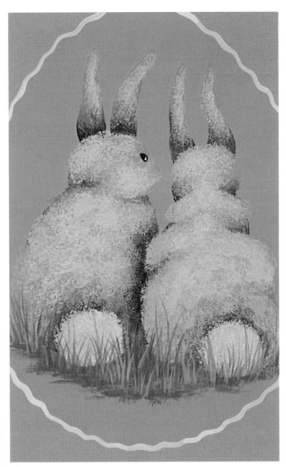

6 Stipple the grassy area beneath the bunnies with Hauser green medium. Let dry. Use the script liner to paint individual blades of grass with Hauser green medium. Rinse the brush, load it with Hauser green light, and repeat. Pull the grass up over the bunnies so that it looks as if they're sitting in it. Don't make every blade the same height or the grass will look as if it's just been mowed. Let dry.

Trim the oval by painting a wavy stripe of titanium white with the script liner. Let dry.

FINISHING

To finish the piece, apply two coats of varnish, letting the first coat dry before applying the second.

Hen

*W*hen your guests walk into your kitchen or dining room and see this fat hen resting comfortably in her basket, they'll immediately think "warm, cozy, and inviting." Drafting pens—the ruling pen and the crow quill, dip, or technical pen— make the bold, graphic look of this painting easy to reproduce and eliminate the need for advanced brushstroke skills. The white comma-stroke border that encloses the completed painting is the most challenging strokework in the piece, requiring time and patience rather than masterful skill with the script liner.

WHAT YOU'LL NEED

Pattern
Page 101

Project
Cutting board from Clover
 Manufacturing *(see
 page 111 for ordering
 information)*

Supplies
SURFACE PREP
#220-grit sandpaper
Tack rag
Paints for staining and
 basecoating: Payne's gray,
 titanium white, and pure
 black *(see list of artists'
 acrylics)*
Cotton rag
Brown paper bag
Painter's tape
Ruling pen
Cork-backed ruler

TRACING AND
TRANSFERRING
Tracing paper
Fine-tip black marker
White and gray transfer paper
Stylus

ARTISTS' ACRYLICS
Titanium white
Yellow light
Medium yellow
Yellow ocher
Burnt sienna
Red light
Naphthol crimson
True burgundy
Burnt umber
Ice blue
Payne's gray
Pure black

ACRYLIC MEDIUMS
Gel retarder
Glazing Medium

BRUSHES/APPLICATORS
Glaze/varnish brushes: two
 1-inch *(one for applying the
 stain, one for varnishing)*
Wash brush: ³/₄-inch
Flats: nos. 4, 10, and 12
Filbert: no. 8
Script liner: no. 2
Round: no. 4

BASIC PAINTING SUPPLIES
Water container
Palette knife
Wax-coated paper palette
Sta-Wet palette
Paper towels

SPECIAL PROJECT SUPPLIES
Crow quill, dip, or technical
 pen
Waterproof black ink

FINISHING
Brush-on satin-sheen acrylic
 varnish

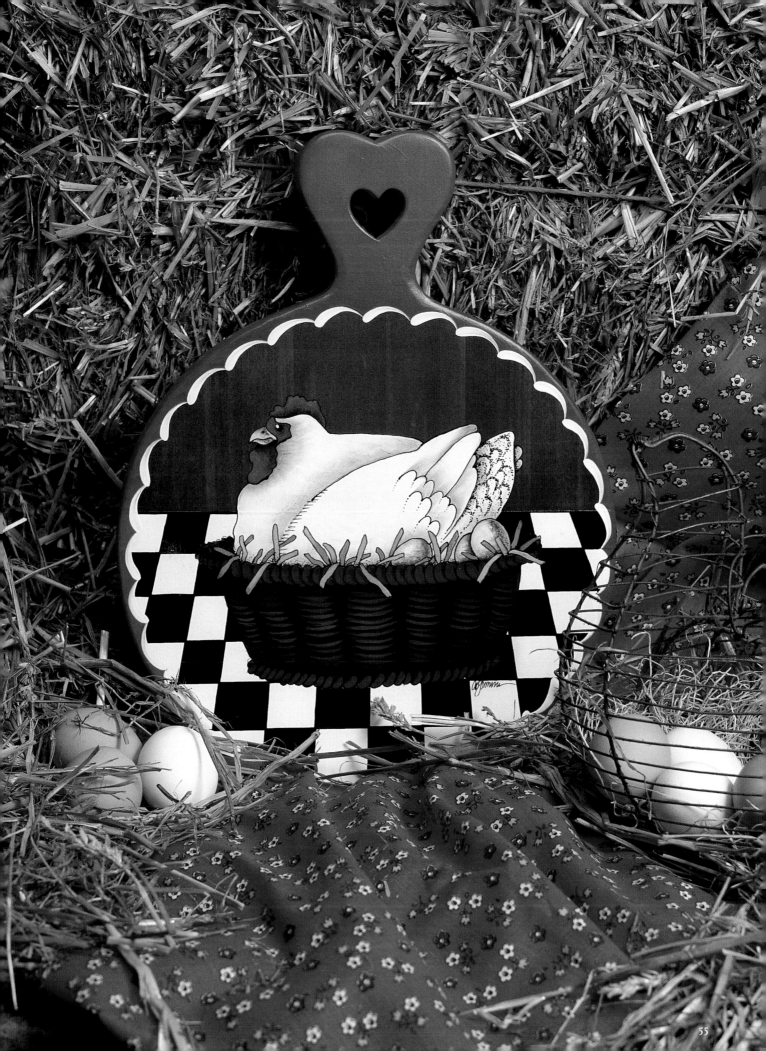

Hen

GETTING READY

Following the instructions on page 39, stain the front of the cutting board with a Payne's gray glaze. Let the stain dry completely, then place a piece of painter's tape across the width of the cutting board so that its bottom edge is about 5 inches from the base of the handle. Paint the board below the tape with three or four coats of titanium white, letting each one dry before applying the next. Remove the tape when the last coat of paint has dried.

Trace the checkerboard portion of the pattern, then transfer it to the surface with gray transfer paper. Stripe the blocks of the checkerboard with pure black according to the instructions on page 44. Stripe all of the horizontal lines first, let them dry, then stripe the vertical lines. Once the striping is dry, use the no. 10 flat brush to paint every other square with pure black. Let dry.

Trace the outlines of the other elements of the pattern, then transfer them to the surface with white transfer paper.

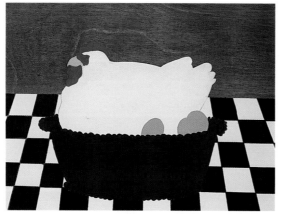

1 Undercoat the hen and the basket with the following colors, using the largest flat brush that you can comfortably maneuver within any given area:
- *For the hen,* use titanium white.
- *For the comb and wattle,* use naphthol crimson.
- *For the beak,* use medium yellow.
- *For the basket,* use burnt umber.
- *For the eggs,* use titanium white + a touch of burnt umber.

 Let the undercoat dry before proceeding.

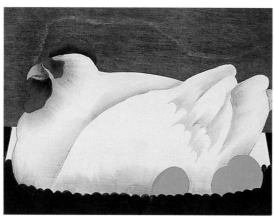

2 Use gray transfer paper to retransfer the dividing lines within the hen, the basket, and the eggs. Apply the shading, again using the largest flat brush that you can fit into a specific area, but this time sideloading the colors specified below. You may find this step easier if you coat each area with a thin layer of gel retarder before you work on it.
- *For the hen,* use a mixture of ice blue + pure black to define the feathers and to create depth around the eye and wattle.
- *For the comb, wattle, and eye,* apply true burgundy to the lines between these areas and the hen's body.
- *For the beak,* use burnt sienna to establish a narrow area of pure medium yellow between the beak and the eye, and to create a line between the top and bottom bill.

3 Shade the remaining elements with a sideloaded flat brush.
- *For the basket,* apply pure black to the inside, to the vertical spokes on the side, and along the coiled rims at the top and bottom.
- *For the eggs,* apply the shading in two layers. First, apply a layer of burnt sienna to about half of each egg on its right side, let it dry, then apply a layer of burnt umber over about half the width of the first layer.

 Make sure that all of the shading is completely dry before you begin highlighting.

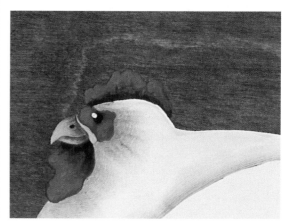

4 Highlight the pattern as follows (note that the hen requires no additional highlighting):
- *For the comb, wattle, and eye,* use the filbert brush to dab on first some naphthol crimson, then some red light along the points of the comb and on the front of the eye area and the wattle. Let dry. Use the script liner brush to undercoat the eyeball with pure black; once dry, highlight it with titanium white.
- *For the beak,* use a flat brush sideloaded with yellow light + titanium white to emphasize the front of the beak above and below the dividing line between the top and bottom bills. Let dry, then use the handle end of the brush to paint the nostril with pure black.

FINISHING

Paint the handle and the trim with three coats of naphthol crimson, letting each one dry before applying the next. Use the round brush to embellish the circumference of the pattern with a border of titanium white comma strokes. Finish the entire cutting board with two coats of varnish, letting the first coat dry before applying the second.

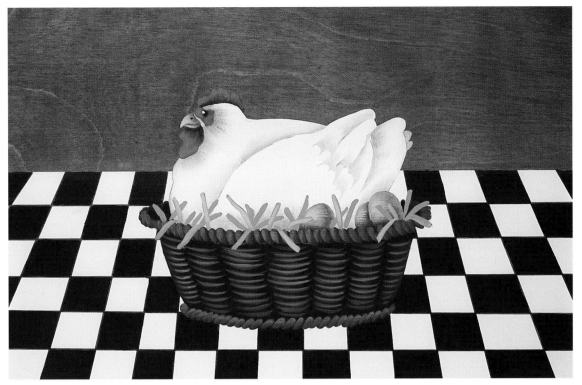

5 Finish highlighting the rest of the elements:
- *For the eggs,* lighten a little of the undercoat color (see step 1) with titanium white, sparsely load the filbert brush with it, then highlight the left side of each egg. Paint a reflected light on the right edge of the two foremost eggs with a sideload of ice blue on a no. 8 flat.
- *For the basket,* use the filbert sparsely loaded with burnt sienna to paint each individual reed on the side and rim of the basket. Let dry, then repeat with yellow ocher. Use the script liner to undercoat the straw with yellow ocher, let dry, then highlight it with yellow light.

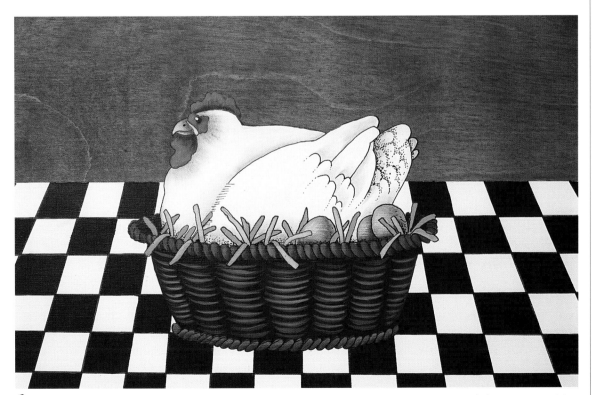

6 Use the crow quill, dip, or technical pen to outline the hen-and-basket portion of the pattern with black ink, then to draw in any remaining details. Work the pen with a stippling motion to define the shapes of the hen's rear feathers. Intersperse a few casual lines among the reeds of the basket.

Dog

This project is a gift for someone who loves you unconditionally. Next to his dish, it will be his most cherished possession. Who is it? Your dog, of course. The dog in this pattern represents the most popular "breed" in the world—the mutt. Adjust the palette so that the painting looks more like your own "best friend." The texturized finish is easy to create and accents the piece nicely. (See page 38 for detailed instructions.) Feel free to change the colors to suit your taste—and your friend's, too.

WHAT YOU'LL NEED

Patterns
Page 102

Project
Tea chest/treat box from PCM Studios *(see page 111 for ordering information)*

Supplies

SURFACE PREP
#220-grit sandpaper
Tack rag
Paints for basecoating and texturizing: lipstick red *(bright, medium-value red acrylic or latex)* and burnt carmine *(see list of artists' acrylics)*
Plastic wrap

TRACING AND TRANSFERRING
Tracing paper
Fine-tip black marker
White transfer paper
Stylus

ARTISTS' ACRYLICS
Titanium white
Turner's yellow
Burnt carmine
Burnt umber
Asphaltum
Ice blue
Hauser green medium
Hauser green light

CRAFT ACRYLICS
Sky blue *(light, bright blue)*

ACRYLIC MEDIUMS
Glazing Medium
Gel retarder

BRUSHES
Wash brushes: ³/₄-inch
Glaze/varnish brushes: two 1-inch *(one for applying the texturizing glaze, one for varnishing)*
Flats: nos. 8 and 10
Script liner: no. 2

BASIC PAINTING SUPPLIES
Water container
Palette knife
Sta-Wet palette
Wax-coated paper palette
Paper towels

SPECIAL PROJECT SUPPLIES
Ruling pen
Cork-backed ruler
Pencil
Crow quill, dip, or technical pen
Waterproof brown ink

FINISHING
Brush-on satin-sheen acrylic varnish

Dog

GETTING READY

Sand, tack, and base-coat the box according to the instructions on page 36. You'll probably need to apply at least three coats of lipstick red acrylic to achieve opaque coverage. Be sure to allow sufficient drying time between coats.

Texturize the entire box with a burnt carmine glaze, following the instructions on page 38.

I Trace the pattern, then transfer the circle to the surface, closing the gaps created by the dog's legs and tail. Use the wash brush to undercoat the circle with sky blue. Let dry, then apply a second coat. While the second coat is still wet, pick up some ice blue on the brush and casually blend it into the top half of the circle. Repeat with a little titanium white. Let dry.

2 Transfer the outline of the dog to the box, then use the no. 8 flat to undercoat it with a very light tan mixture of titanium white + asphaltum + a touch of burnt umber. Once the undercoat is dry, transfer the interior lines of the pattern to the dog.

3 Apply a wash of asphaltum to the dog according to the instructions on page 30, in this case using short, choppy strokes instead of smooth ones. Let dry. Using a no. 8 flat brush sideloaded with burnt umber, shade the dog along the back, at the base of the tail, along the rump, down the back right leg, and in front of the right rear loin. Reload the brush, then shade the back left leg, the two front legs, and around the ear. Let dry.

4 At this point, you may use the crow quill, dip, or technical pen and brown ink to give the dog a scruffy fur texture. (Always test the pen on a piece of scrap paper so that it won't blob or drip on your painting.) I like the casual, almost cartoonish look this step gives the pattern. Make sure that the short lines of the fur follow the dog's contours. Even if you decide not to add fur, use the pen to add the eye and nose. Let dry, then highlight the eye with titanium white and the nose with the undercoat color (see step 2).

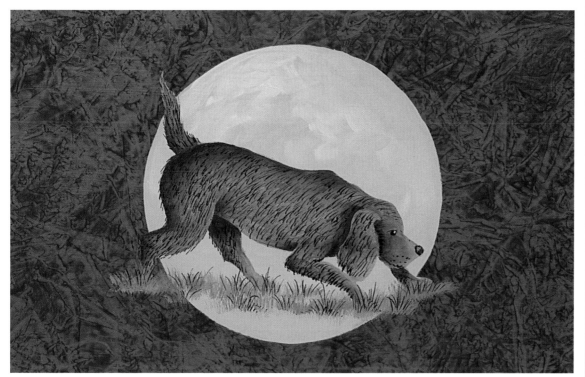

5 Thin some Hauser green light with a little water, then load the no. 10 flat brush with the thinned paint. Tap the chisel edge of the brush on the palette so that the hairs flare open slightly, then touch the bristles to the surface and flick the brush upward to create a little clump of grass. Repeat to paint the entire ground, then add a few random clumps in Hauser green medium. Let dry. To visually connect the dog with the grass, use the pen and ink to draw some longer blades of grass within each clump.

Fish

*T*here's nothing better than a good fish story, but the fish in this project is one that won't get away. This project makes use of a technique known as pen and ink, which allows beginner artists to create realistic paintings with little effort. The shading and other details are drawn in with a crow quill, dip, or technical pen before the painting is begun, then several thinned washes of color are applied over it. You can make the drawing as detailed as you like—in fact, there's almost no way you can go too far with it. You can use the pen-and-ink technique with almost any pattern in this book.

WHAT YOU'LL NEED

Pattern
Page 103

Project
Wooden plaque from
Gretchen Cagle Publications
*(see page 111 for ordering
information)*

Supplies

SURFACE PREP
#220-grit sandpaper
Tack cloth
Paints for staining and
basecoating: green umber
and burnt umber *(see list of
artists' acrylics)* and mush-
room *(light-to-medium
grayish brown acrylic or
latex)*
Cotton cloth
Brown paper bag

**TRACING AND
TRANSFERRING**
Tracing paper
Fine-tip black marker
White transfer paper
Stylus
Chalk

ARTISTS' ACRYLICS
Titanium white
Medium yellow
Burnt sienna
Alizarin crimson
Ice blue
Aqua
Prussian blue
Sap green
Green umber
Burnt umber
Pure black

CRAFT ACRYLICS
Silver sterling *(metallic silver)*
Peridot *(deep yellowish
green)*

ACRYLIC MEDIUMS
Gel retarder
Glazing Medium

BRUSHES
Glaze/varnish brushes:
two 1-inch *(one for
applying the stain, one
for varnishing)*
Flats: nos. 4, 10, and 12
Script liner: no. 2

**BASIC PAINTING
SUPPLIES**
Water container
Palette knife
Sta-Wet palette
Wax-coated paper palette
Paper towels

**SPECIAL PROJECT
SUPPLIES**
Crow quill, dip, or
technical pen
Waterproof black ink

FINISHING
Brush-on semigloss
acrylic varnish

Fish

GETTING READY

Following the instructions on page 39, stain the curved portion of the plaque with a green umber stain, then stain the frame with a burnt umber stain. Let dry.

Trace the pattern, then transfer the outline of the fish to the plaque with white transfer paper.

I Use the no. 10 or 12 flat brush to undercoat the fish with three coats of silver sterling, letting each dry before applying the next.

Carefully chalk the back of the tracing, then transfer the outlines of the fins, gills, eye, and mouth to the surface with a stylus. Use the crow quill or technical pen to ink the outlines, then use it to add shading and other details. (Do not ink the details in the eye.) Work slowly and carefully, using the pattern on page 103 as a reference.

2 Thin some peridot with water to a thin, translucent consistency. Use the no. 10 flat brush to apply the thinned paint with a dabbing motion to the center of the fish, from behind the eye to the end of the rear dorsal fin. Let dry.

3 Apply a thin coating of gel retarder to the entire fish. While the gel is wet, use the no. 4 flat to apply a mixture of sap green + a touch of pure black along the top of the fish from behind the mouth to the tail fin, then gently blend it downward over the rest of the body. Color the inside of the mouth with this mixture as well. Accent the upper and lower jaws with a thin application of aqua. Let dry.

FINISHING

Use the wash brush to paint the frame with mushroom acrylic. Let dry. Sand the frame with #220-grit sandpaper to reveal the umber stain as well as some of the raw wood, then wipe it with a tack cloth. Finish the entire plaque with two coats of varnish, letting the first coat dry before applying the second one.

4 Use the no. 12 flat to apply a second coat of blending gel to the entire fish. Apply some green umber into the wet gel along the top of the fish, then use a dabbing motion to blend it downward over half the body. Also shade the fins with green umber. Let dry.

Use the same brush sideloaded with a mixture of green umber + alizarin crimson to intensify the shading along the top of the body, behind the eye, behind the cheek, and on the tips of the fins. Let dry.

5 Sparsely accent the tips of the fins with thinned alizarin crimson applied with a no. 10 flat brush. If the alizarin crimson seems too strong, tone it down with a touch of green umber.

Use the no. 2 script liner to paint the eye, letting each step dry before proceeding to the next. Begin by undercoating the eye with medium yellow. Shade the right side with thinned burnt sienna. Paint the pupil with pure black, then highlight it with titanium white.

Transfer the bubbles to the surface (if you haven't already). Sideload the no. 10 flat with green umber + a tad of pure black, then lightly stroke the loaded side of the brush alongside the right edge of each bubble. Let dry.

6 Use the no. 4 flat to apply a layer of gel retarder to each bubble. Into the wet gel, stroke a scant amount of Prussian blue + burnt umber on the right half and titanium white on the left half. While the gel is still wet, sideload the brush with ice blue and apply it along the right edge, then use it to soften the outside edges of the bubble. Let dry, then use the script liner to paint the highlights with titanium white.

Cat

*T*he cat's dual personality—graceful and self-possessed one minute, playful and mischievous the next—makes it a very popular pet. The beauty of this project lies in how minimally the cat is painted. After its face and tabby markings are painted, the cat's form is established with two antiquing glazes: The first is applied directly to the cat, while the second is used to accentuate its silhouette. If you want to create a portrait of the cat in your life, you can paint this pattern with the techniques featured in the Dog, Fish, and Squirrel projects, using any palette.

WHAT YOU'LL NEED

Patterns
Page 104

Project
Wooden plate from Wayne's Woodenware *(see page 111 for ordering information)*

Supplies

SURFACE PREP
#220-grit sandpaper
Tack rag
Paints for staining and basecoating: asphaltum *(see list of artists' acrylics)*; French vanilla *(very light, dull yellow-beige acrylic or latex)* and metallic silver acrylic or latex
Cotton rag
Brown paper bag

TRACING AND TRANSFERRING
Tracing paper
Fine-tip black marker
Gray and white transfer paper
Stylus

ARTISTS' ACRYLICS
Titanium white
Burnt sienna
Red light
Naphthol crimson
Asphaltum
Burnt umber
Hauser green light
Payne's gray
Pure black

ACRYLIC MEDIUMS
Gel retarder
Glazing Medium

BRUSHES
Glaze/varnish brushes: two 1-inch *(one for applying the stain, one for varnishing)*
Wash brush: ³/₄-inch
Flats: nos. 4, 10, and 12
Filbert: no. 8
Script liner: no. 2
Mop: ³/₄-inch
Round: no. 4

BASIC PAINTING SUPPLIES
Water container
Palette knife
Sta-Wet palette
Wax-coated paper palette
Paper towels

FINISHING
Brush-on satin-sheen acrylic varnish

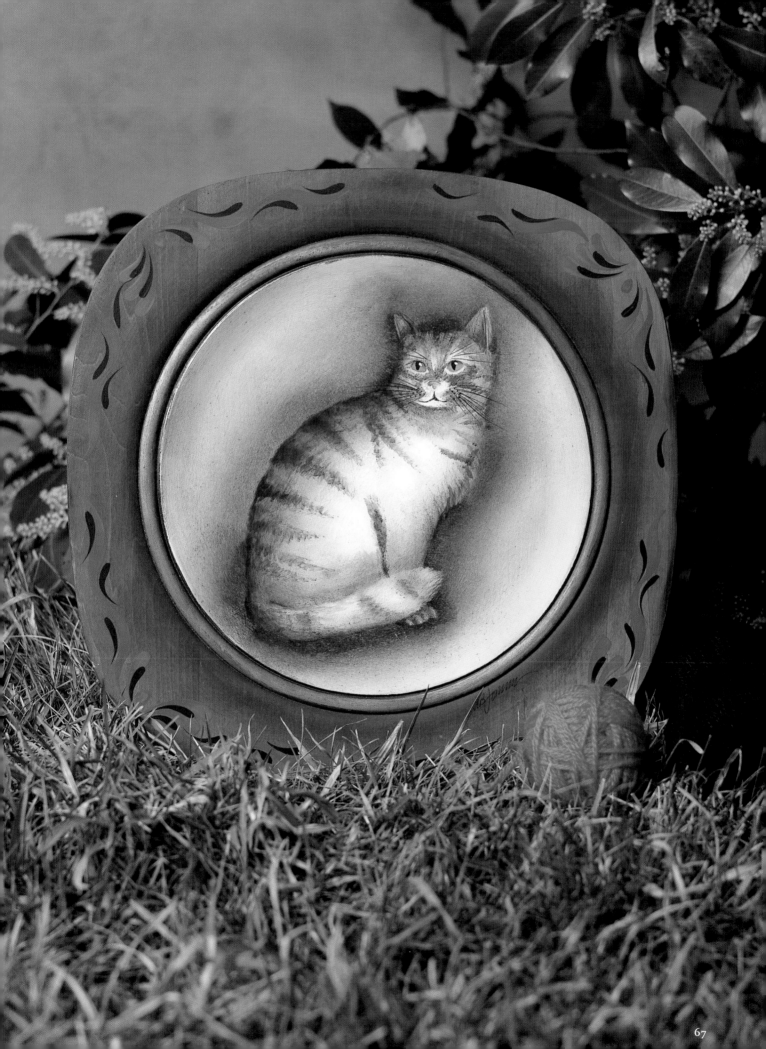

Cat

Stain the rim of the plate with an asphaltum glaze according to the instructions on page 39. Use the wash brush to apply two or three coats of French vanilla to the center of the plate. Be sure to allow adequate drying time between coats. Paint the bead with metallic silver.

Trace the pattern for the cat, then transfer just its basic outlines to the surface with gray transfer paper.

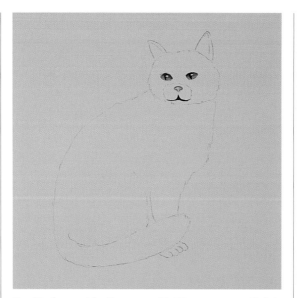

I Undercoat both eyes with Hauser green light. Let dry, then very lightly shade the top half of each eye with the script liner sideloaded with pure black. Use the script liner to paint the pupils with a mixture of pure black + burnt umber. Apply the titanium white highlight in each eye with the script liner.

Undercoat the nose with a light pink mixture of titanium white + burnt sienna + red light. Let dry. Using the script liner, shade the top and right side with a bit of burnt sienna, then highlight the left side with titanium white. Paint the mouth with thinned pure black applied with the script liner.

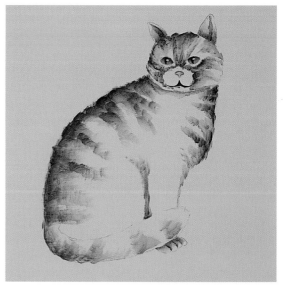

2 Thin small amounts of pure black and Payne's gray separately with water until translucent. Using the largest flat brush that you can comfortably fit into each area, begin applying the tabby markings, starting with the face, then continuing with the body. Use the pattern on page 104 as a guide to placement. First apply the markings somewhat lightly in Payne's gray. (It's best to err on the side of caution and make the markings too light, since you can always reinforce them with a second application.)

Once the first set of markings is dry, apply pure black to the shaded areas: between the eyes, around the muzzle, along the back, on the curve of the tail, on the chest, and behind the front leg.

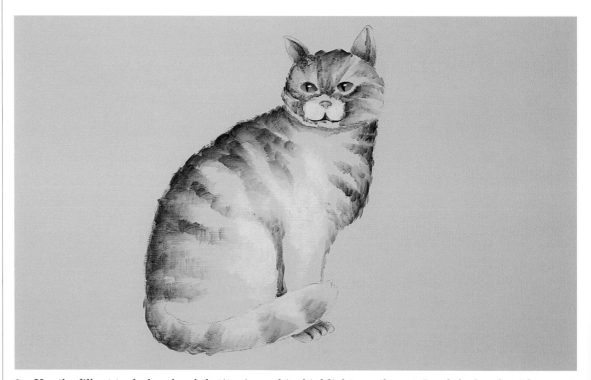

3 Use the filbert to drybrush subtle titanium white highlights on the cat. Load the brush with a scant amount of paint, then gently skim it over the muzzle and on the shoulder, loin, and tail. Let dry.

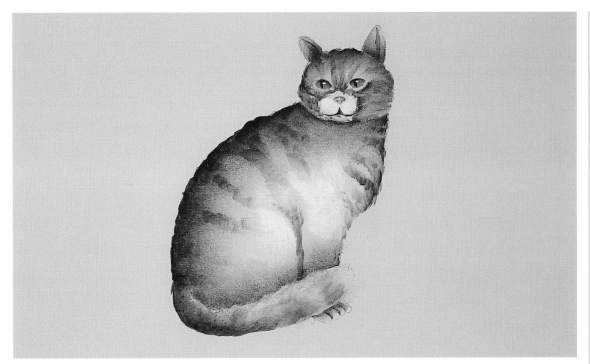

4 The cat's interior shape is given depth with an antiquing glaze. Using equal amounts of burnt umber and pure black, prepare the glaze according to the instructions on page 42. Use the no. 12 flat brush to apply the glaze beneath the chin, along the back, to the curve in the tail, and immediately above the tail on the loin and the leg. Gently stipple the edge of the shading with the mop brush to soften it and draw it into the interior of the body. On the head, apply the glaze at the base of the ears and around the perimeter of the face, then stipple the application, making sure to leave the nose and the highlights on the muzzle untouched. Let dry completely.

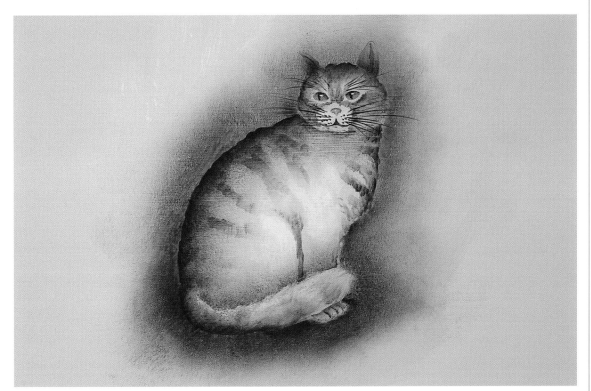

5 In this step, a second antiquing glaze is applied to define the cat's exterior. Deepen the color of the antiquing mixture prepared in step 4 by adding a little burnt umber. Apply it to a small area around the edge of the cat, then stipple it with the mop brush, drawing the color away from the body to soften it. Repeat this step around the entire cat.

Use the script liner to paint whiskers in pure black.

FINISHING

Antique the silver bead with the glaze that was used in step 5. Let dry.

Trace the stroke pattern, then transfer it to all four corners of the plate rim with white transfer paper. Use the round brush to paint the red strokes with a mixture of naphthol crimson + burnt sienna; let dry, then highlight the comma strokes with red light. Paint the dark strokes with pure black. Let dry.

Finish the plate with two coats of varnish. Let the first coat dry before applying the second.

Pigs

*T*he word "pig" has many connotations, most of them negative. Pigs are routinely portrayed as dirty and stupid, when they are really meticulously clean—they roll in mud to protect themselves from the heat and exposure to the sun—and quite intelligent. In fact, some varieties of pig can be trained to perform tricks and simple tasks, and some can even be housebroken and kept as pets. For this project, I painted an unusually acrobatic pair of porkers in a whimsical folk-art style, then accented the piece with strokework and an opaque antiquing glaze. When painting in a style like this, take a lighthearted approach, and don't be too concerned with anatomy.

WHAT YOU'LL NEED

Patterns
Page 105

Project
Recipe box from The Cutting Edge *(see page 111 for ordering information)*

Supplies

SURFACE PREP
Primer
#400-grit sandpaper
Tack rag
Paint for basecoating: light periwinkle *(bright, light-to-medium value blue acrylic or latex)*

TRACING AND TRANSFERRING
Tracing paper
Fine-tip black marker
White transfer paper
Stylus

ARTISTS' ACRYLICS
Titanium white
Yellow light
Turner's yellow
Yellow ocher
Red light
Burnt sienna
Burnt umber
Brilliant ultramarine
Ice blue
Aqua
Payne's gray
Pure black

CRAFT ACRYLICS
Soldier blue *(dark grayish blue)*

ACRYLIC MEDIUMS
Gel retarder

BRUSHES
Glaze/varnish brushes: two 1-inch *(one for priming and basecoating, one for varnishing)*
Wash brush: 3/4-inch
Flat: no. 10
Script liner: no. 2
Filbert: no. 8

BASIC PAINTING SUPPLIES
Water container
Palette knife
Sta-Wet palette
Wax-coated paper palette
Paper towels

SPECIAL PROJECT SUPPLIES
Dishwashing liquid (such as Dawn)
#0000 steel wool

FINISHING
Brush-on satin-sheen acrylic varnish

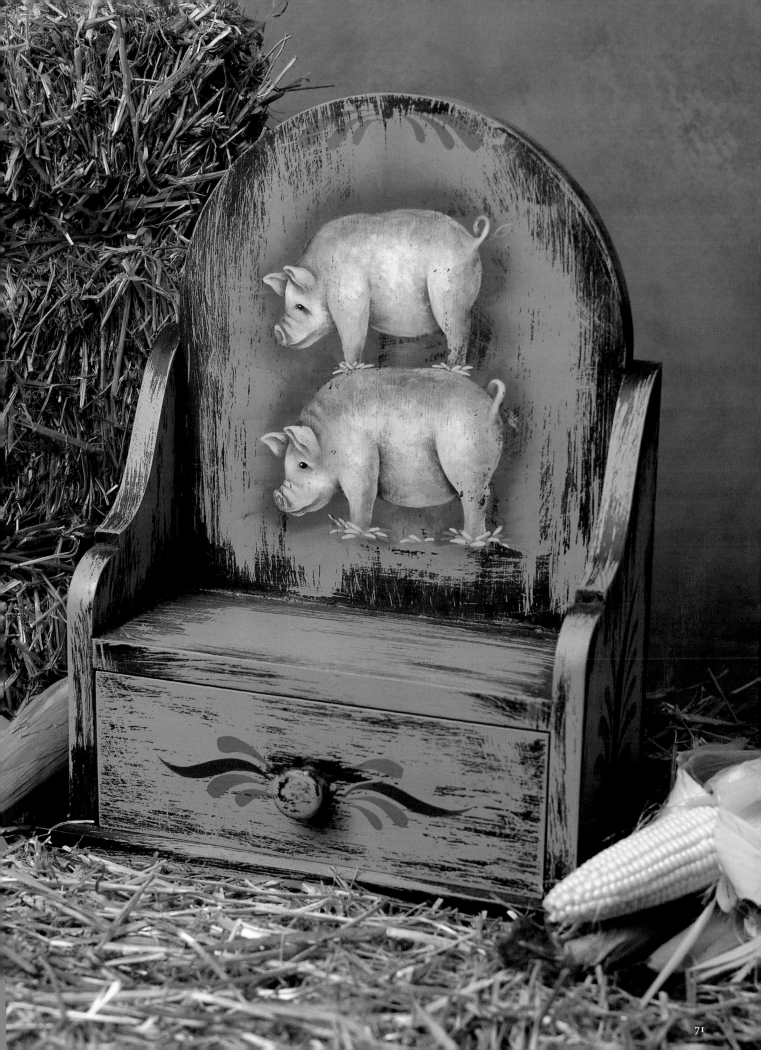

Pigs

GETTING READY

Prime, sand, tack, and basecoat the recipe box according to the instructions on page 36. Use a glaze/varnish brush to apply three coats of light periwinkle, letting each coat dry before applying the next.

Trace the pattern, then transfer it to the surface. Include all of the pigs' interior lines (but not the shading).

1 Moisten the wash brush with gel retarder, then sideload it with soldier blue. Shade each pig's outline by gently patting the color around it, making sure that the blue is strongest in the area immediately surrounding it, then gradually fades away. Let dry. If necessary, retransfer any lines that were covered by the shading.

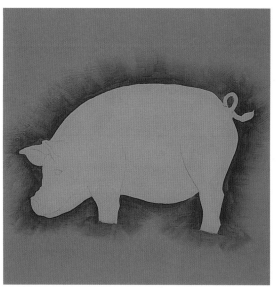

2 Use the flat brush to undercoat the pigs with an intense pink mixture of titanium white + burnt sienna + a tad of red light. Let the first coat dry, then apply a second, stippling it slightly to create a delicate texture. Let dry thoroughly before proceeding.

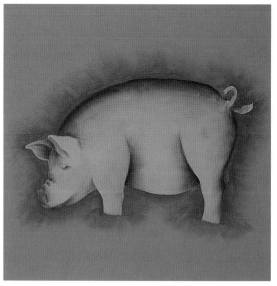

3 Sideload the flat brush with burnt sienna, then use it to shade each pig along the top of its back, between and inside its ears, on the tip of its snout, under its chin, and beneath its eye. Emphasize the belly by shading in front of and behind the legs. Finally, don't forget to shade the bend in the tail. Let the shading dry; if needed, strengthen specific areas with a second application.

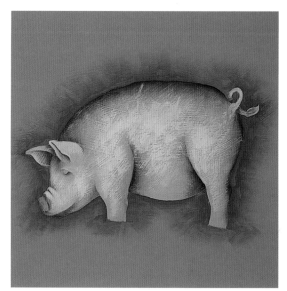

4 Use the filbert to drybrush highlights on the pigs. Begin by skimming the edges of the shading with a scant amount of the undercoat color (see step 2). Let dry, then repeat, lightening the pink each time with a small amount of titanium white and applying the resulting color to a progressively smaller area. The peak of the highlight, which should be pure white, should extend along the center of each pig from the cheek to the shoulder to the rump.

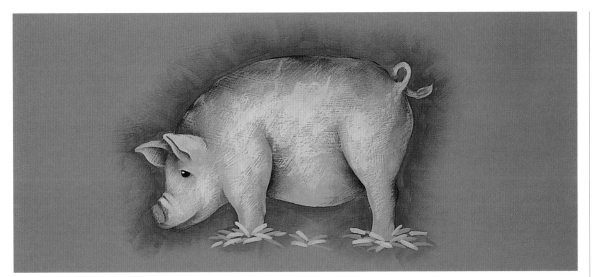

FINISHING

Apply two coats of varnish, letting the first coat dry before applying the second.

5 The pigs may be accented with any colors. I used the filbert to apply accents of ice blue, aqua, and aqua + yellow light along the back, on the rump, and under the belly of each pig.

Use the script liner to paint the eyes. Undercoat them with a mixture of pure black + burnt umber. Let dry, then highlight with a dot of titanium white. Use the script liner to paint a few strands of straw with yellow ocher. Once the first strands have dried, paint a second set of strands with Turner's yellow.

Trace the stroke designs, then transfer them to the front of the drawer and the top and sides of the box. Using the script liner, paint the comma strokes with a mixture of burnt sienna + titanium white, the S strokes with Payne's gray + brilliant ultramarine, and the light stroke on the large S stroke (in the side pattern) with the comma stroke mixture lightened with titanium white.

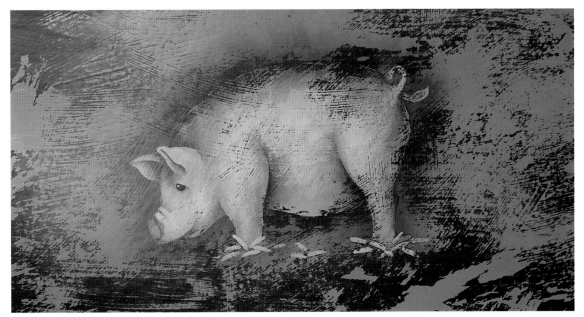

6 Apply three coats of varnish to protect the piece during the antiquing process, letting each one dry before applying the next. To create the antiquing slurry, combine equal parts burnt umber, Payne's gray, and dishwashing liquid, then mix with the palette knife. Add a little water so that the mixture flows smoothly. When you brush on the slurry, it will cover the painting completely. Since this is a messy process, get it over with by antiquing the entire box at once. Let the slurry dry for about an hour, or until it has lost its sheen, at which point it should be dry to the touch.

Starting in the center of the pigs and working outward, rub the surface with the steel wool. If the antiquing is difficult to remove, wipe the surface with a wet paper towel, then continue rubbing with the steel wool. You can remove as much or as little of the antiquing as you like: Remove it from high-lighted areas and leave it almost intact over shaded ones, or remove nearly all of it from the painting itself, then leave it heavy immediately surrounding the design before creating a gradual fade. If you don't like the result, try to remove all of it, then repeat this step. Let the antiquing dry overnight.

Horse

The horse was domesticated thousands of years ago, and has served humans faithfully since then as a draft and pack animal. The graceful horse has also given us pleasure, impressing us with its speed and physical beauty. This project features a chestnut (reddish brown horse) with a blaze (a broad white stripe on its nose); if desired, you can adapt the palette to paint a white, a gray, or a Palomino. If you can't find the handmade paper I've used for the painting surface, simply basecoat or stain the lid with a color of your choice.

WHAT YOU'LL NEED

Pattern
Page 106

Project
Wooden box from Bush's Smoky Mountain Wood Products *(see page 111 for ordering information)*

Supplies

SURFACE PREP
Primer
#400-grit sandpaper
Tack rag
Paint for basecoating: maple syrup *(medium-to-dark brown acrylic or latex)*

TRACING AND TRANSFERRING
Tracing paper
Fine-tip black marker
Gray transfer paper
Stylus

ARTISTS' ACRYLICS
Titanium white
Warm white
Light red oxide
Burnt umber
Asphaltum
Ice blue
Pure black

ACRYLIC MEDIUMS
Gel retarder
Glazing Medium

BRUSHES
Wash brush: ³/₄-inch
Glaze/varnish brushes: two 1-inch *(one for applying the Mod Podge, one for varnishing)*
Flat: no. 10
Script liner: no. 2

BASIC PAINTING SUPPLIES
Water container
Palette knife
Sta-Wet palette
Wax-coated paper palette
Paper towels

SPECIAL PROJECT SUPPLIES
Ogura rice paper OR other heavily textured Oriental handmade paper
X-Acto knife OR razor blade
Mod Podge *(combination glue/varnish)*, gloss sheen
Ruling pen
Cork-backed ruler

FINISHING
Brush-on satin-sheen acrylic varnish

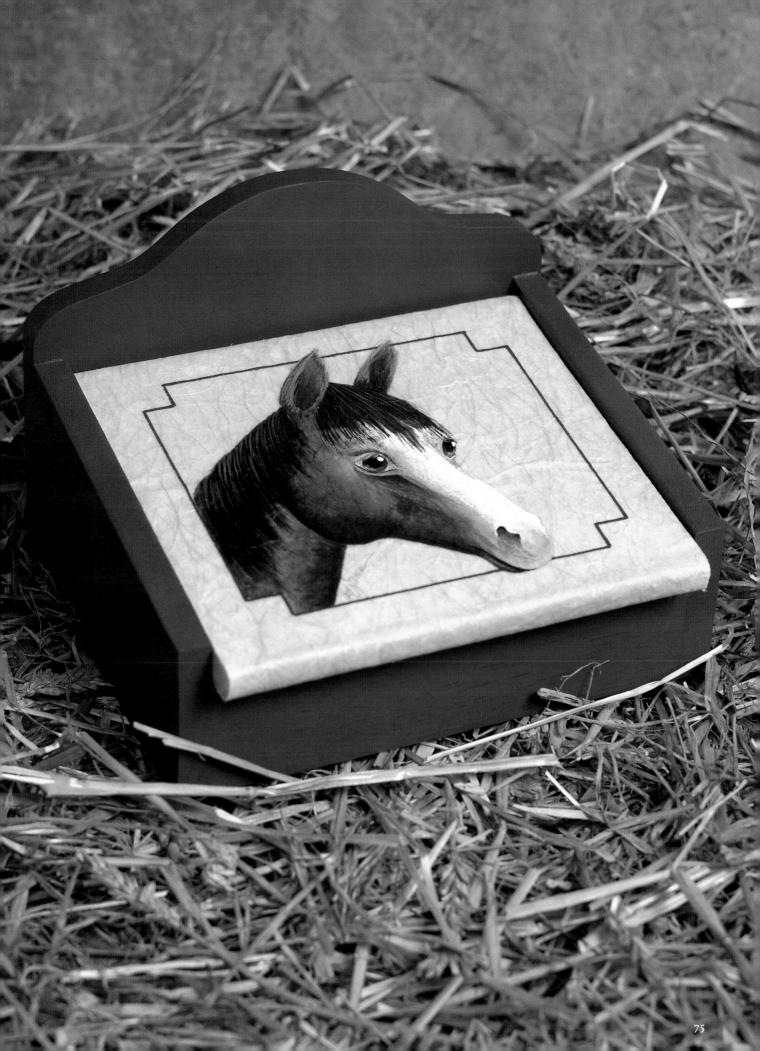

Horse

GETTING READY

Prime, sand, tack, and basecoat the box (except for the lid) with two coats of maple syrup basepaint according to the instructions on page 36, letting the first coat dry before applying the second.

Cut the handmade paper so that it measures 1 inch larger on all sides than the box lid. Use a glaze/varnish brush to apply an ample coat of Mod Podge on the top of the lid, as well as on the rounded front edge and about an inch of the underside. While the Mod Podge is wet, place the paper on the lid, then press it onto the wood with your hands, shaping the extra paper at the front over the rounded edge. Immediately seal the paper with a coat of Mod Podge, then let dry overnight. Use an X-Acto knife or razor blade to trim off the excess paper at the back and on the sides of the lid.

1 Trace the pattern, then transfer the shape surrounding the horse to the surface, closing the gaps created by the ears and muzzle. Following the instructions on page 44, use the ruling pen and the maple syrup basepaint to stripe the shape. Stripe all the horizontal lines first, let dry, then stripe the vertical ones. When the striping is completely dry, transfer the horse to the surface.

2 Use the flat brush to undercoat the forehead and muzzle with warm white, then to apply a dull brown mixture of warm white + asphaltum to the rest of the head and neck. Gently blend the areas where the two colors meet. Let dry.

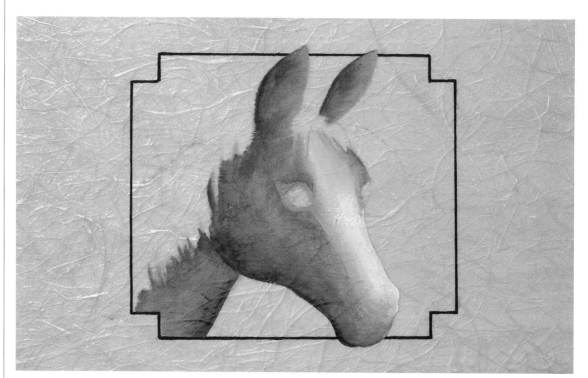

3 Doubleload the flat brush with asphaltum and gel retarder. Shade the sides of the ears, along the bottom of the cheek and the muzzle, and down the front of the neck. Let dry.

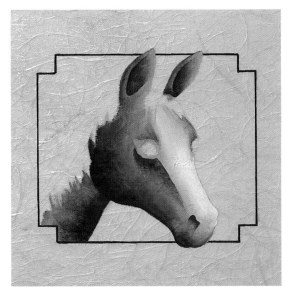

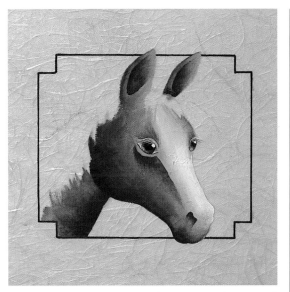

FINISHING

Finish the entire box with two coats of varnish, letting the first coat dry before applying the second.

4 Rinse the brush, then doubleload it with burnt umber and gel retarder. Strengthen the shading along the bottom of the cheek and the muzzle and on the front of the neck, making sure that the cheek is darker than the neck where the two adjoin so that the difference between them is clear. Reload the brush if needed, then use it to shade the insides of the ears, feathering the color out into the ear from the base; beneath the eye, softening the color by blending it along the stripe; and the nostril.

5 When painting the eye, let each application of paint dry before applying the next. Undercoat the whites of the eyes with a mixture of warm white + burnt umber. Paint the irises first with light red oxide, then with a layer of asphaltum thinned with water. Shade the top half of each eye with a sideload of burnt umber. Paint the pupils with pure black and the highlights with titanium white. Use a dry script liner to create a faint light area at the very bottom of each iris by applying a tiny bit of ice blue. Paint the eyelashes with a very pale mixture of titanium white + ice blue.

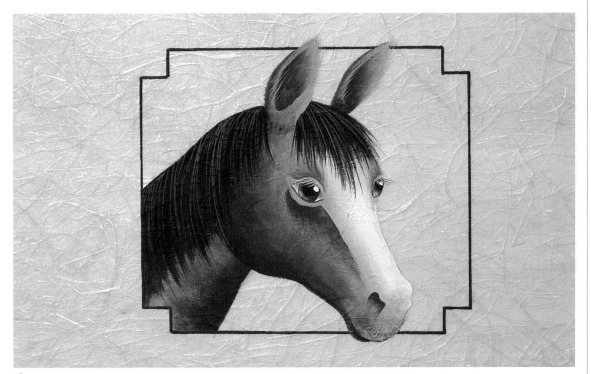

6 Gently undercoat the mane by drybrushing it with burnt umber. Let dry. Use the script liner to paint individual hairs in burnt umber, burnt umber + pure black, and pure black. Add a few ice blue highlight hairs to give the mane and the insides of the ears shine and definition. (Don't add too many of these, or the mane will look gray instead of black.) Accent the very end of the muzzle by drybrushing on a scant amount of ice blue.

Cow and Calf

A nursing calf is a common sight in many farming communities throughout the United States. The black-and-white cows in this project were inspired by the beautiful holsteins I saw while on a trip to Holland, where I visited a dairy farm and cheese factory. The family that ran the farm pampered their cows, and the children even played with them. Pamper yourself and a friend by filling your finished picnic basket with your favorite lunch and enjoying it alfresco.

WHAT YOU'LL NEED

Pattern
Page 107

Project
Picnic basket from Pesky Bear *(see page 111 for ordering information)*

Supplies

SURFACE PREP
#400-grit sandpaper
Tack rag
Paints for basecoating: mystic green, poetry green, and settler's blue *(see list of craft acrylics)*

TRACING AND TRANSFERRING
Tracing paper
Fine-tip black marker
White transfer paper
Stylus

ARTISTS' ACRYLICS
Titanium white
Yellow ocher
Red light
Naphthol crimson
Asphaltum
Burnt umber
Ice blue
Payne's gray
Pure black

CRAFT ACRYLICS
Mystic green *(light yellow-green)*
Poetry green *(bright, light blue-green)*
Settler's blue *(bright, light, slightly grayed blue)*

ACRYLIC MEDIUMS
Gel retarder

BRUSHES
Flats: nos. 4, 8, and 10
Wash brush: ³/₄-inch
Script liner: no. 2
Filbert: no. 6
Glaze/varnish brush: 1-inch

BASIC PAINTING SUPPLIES
Water container
Palette knife
Sta-Wet palette
Wax-coated paper palette
Paper towels

FINISHING
Brush-on satin-sheen OR gloss acrylic varnish

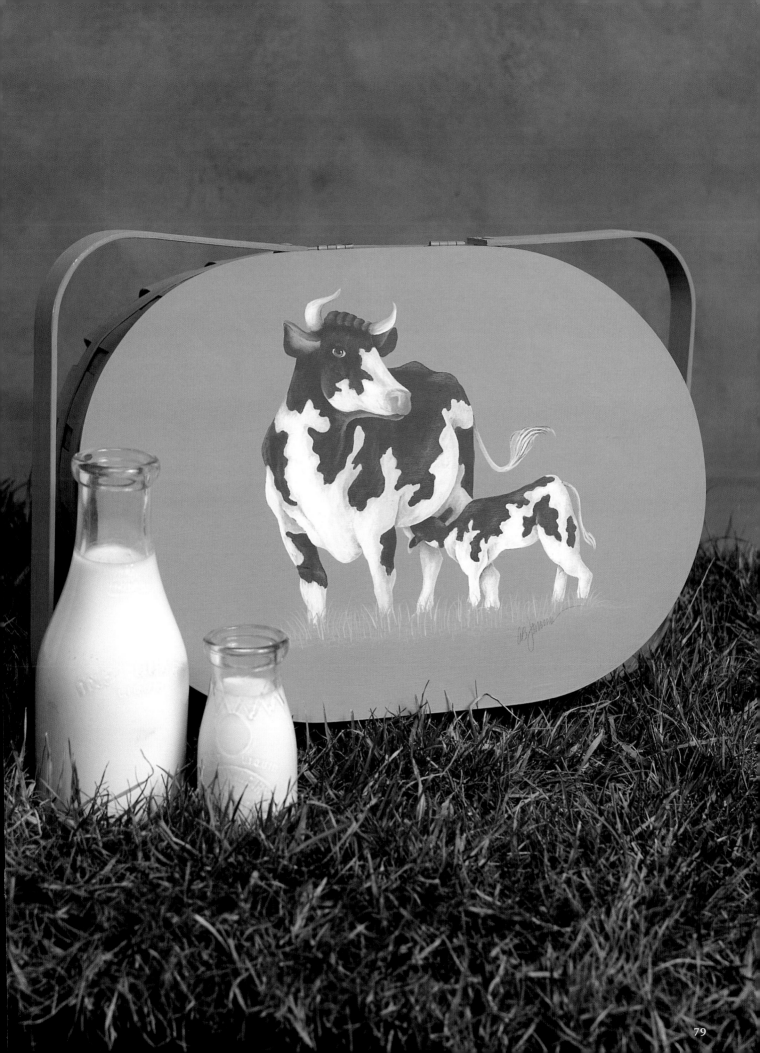

Cow and Calf

GETTING READY

Use the wash brush to basecoat the overlapping splints with poetry green and the underlying splints with mystic green. Let dry, then paint the outer bands, the lid, and the handles with a coat of settler's blue. (If desired, you may use the glaze/varnish brush to basecoat the lid.) Once dry, sand and tack the lid, then apply a second coat.

Trace the pattern, then transfer the outlines of the cow and calf and all of their interior details, with the exception of the shading, which is indicated on the pattern with hatching and crosshatching, and the grass, which will be painted in the last step.

I Combine burnt umber + Payne's gray to create a very dark color that is neither blue nor brown. You also need to make a bluish white mixture of ice blue + titanium white. Use these mixtures to undercoat the black and white areas of the cow and calf, applying them with either the no. 4 or the no. 8 flat brush. Apply the ice blue/titanium white mixture sparingly so that a bit of the background shows through here and there. Let dry.

2 Load the no. 8 flat with gel retarder, sideload it with ice blue, then gently stroke the loaded side of the brush into the dark undercoat mixture. Blend the two colors in the brush by stroking it on a clean area of the wax-coated palette. You're trying to create a light gray, so you may need to repeat the procedure a few times before you hit it right. Use this color to lightly shade the white areas of the cow and calf as shown in the photo on page 79 and as indicated in the pattern on page 107. Let dry. If necessary, repeat this step to intensify selected areas of shading.

3 Drybrush subtle highlights on some of the black areas with the filbert brush. Load the brush with a tad of ice blue, then gently skim the color on the poll (the area between the cow's horns), the ears, the forehead, the muzzle, the throat, the withers, the front legs, the ribs, the rump, and the thigh. On the calf, highlight the head, the ears, and along the back.

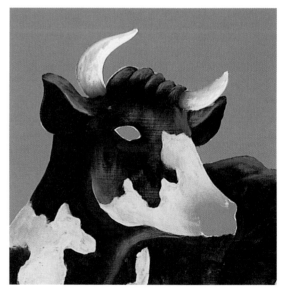

4 Use the script liner to paint the cow's horns. Undercoat them first with ice blue, let dry, then shade them at the base and along the left side with the dark undercoat mixture. Once the shading has dried, highlight the right side with titanium white.

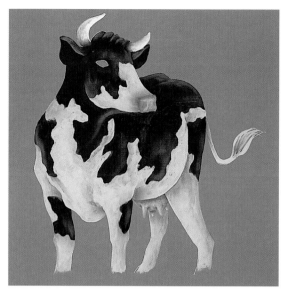

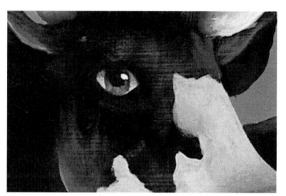

FINISHING

Finish the entire basket with three to four coats of varnish, letting each coat dry before applying the next one.

5 Undercoat the cow's udder and the nose using the no. 4 flat and a dull pink mixture of titanium white + a touch of naphthol crimson + a tad of red light. Let dry, then highlight with titanium white. Shade the nose and udder with a grayish pink (a bit of pink + a touch of dark undercoat mixture). If desired, apply the shading color to the inside of the left ear. (An example of this can be seen in the project photo on page 79.)

6 To paint the eye, use the script liner to apply each element, and let each one dry before applying the next one. Undercoat the sclera (the white of the eye) with a mixture of titanium white + burnt umber. Shade the top half of the sclera with a little burnt umber. Undercoat the iris with yellow ocher, then apply a thin, translucent layer of asphaltum over it. While the asphaltum is still wet, use a clean, damp brush to remove it in radiating lines, working from the center of the eye outward. Shade the top of the iris with burnt umber. Create the pupil by painting a series of tiny dots in the center of the eye with the dark undercoat mixture, then add a few dots of pure black right in the center of the pupil. Highlight the eye by placing a dot of titanium white on the right side of the pupil.

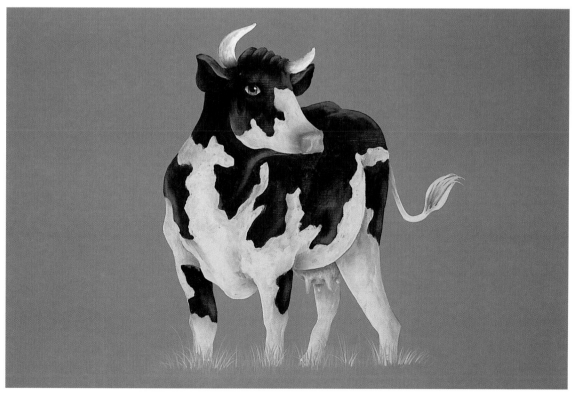

7 Use the wash brush to stipple the first layer of grass with mystic green. Let dry, then repeat with poetry green. The edges of the grassy area should be fluffy and irregular, not harsh or methodic. When the stippling is dry, paint individual blades of grass using the script liner and each of the following colors, which should be thinned to an inklike consistency with water: mystic green, poetry green, poetry green + ice blue, and poetry green + ice blue + titanium white. Let dry.

Squirrel

Degree of Difficulty

*T*he red squirrel shown on the opposite page is doing what squirrels love most—eating! Unlike the gray squirrel, which buries its food in hundreds of places, the red squirrel always hides its food in one spot. You can use this project, a simple Shaker box, to store your jewelry, coins, and other treasures. I stained the surface a warm honey color, which also serves as the squirrel's undercoat. I then painted the squirrel's fur, hair by hair, with a script liner. This technique takes time and patience, but it's an excellent way to develop your brush-handling skills.

WHAT YOU'LL NEED

Pattern
Page 106

Project
Oval Shaker box from Pesky Bear *(see page 111 for ordering information)*

Supplies

SURFACE PREP
#220-grit sandpaper
Tack rag
Paints for staining and fly-specking: asphaltum and burnt umber *(see list of artists' acrylics)*; apple spice *(light, bright red acrylic or latex)*
Cotton rag
Brown paper bag

TRACING AND TRANSFERRING
Tracing paper
Fine-tip black marker
White transfer paper
Stylus

ARTISTS' ACRYLICS
Titanium white
Warm white
Ice blue
Asphaltum
Burnt umber
Pure black

ACRYLIC MEDIUMS
Gel retarder
Glazing Medium

BRUSHES/APPLICATORS
Glaze/varnish brushes: two 1-inch *(one for applying the stain, one for varnishing)*
Old toothbrush
Flats: nos. 8 and 10
Wash brush: 3/4-inch
Script liner: no. 2

BASIC PAINTING SUPPLIES
Water container
Palette knife
Sta-Wet palette
Wax-coated paper palette
Paper towels

FINISHING
Brush-on satin-sheen acrylic varnish

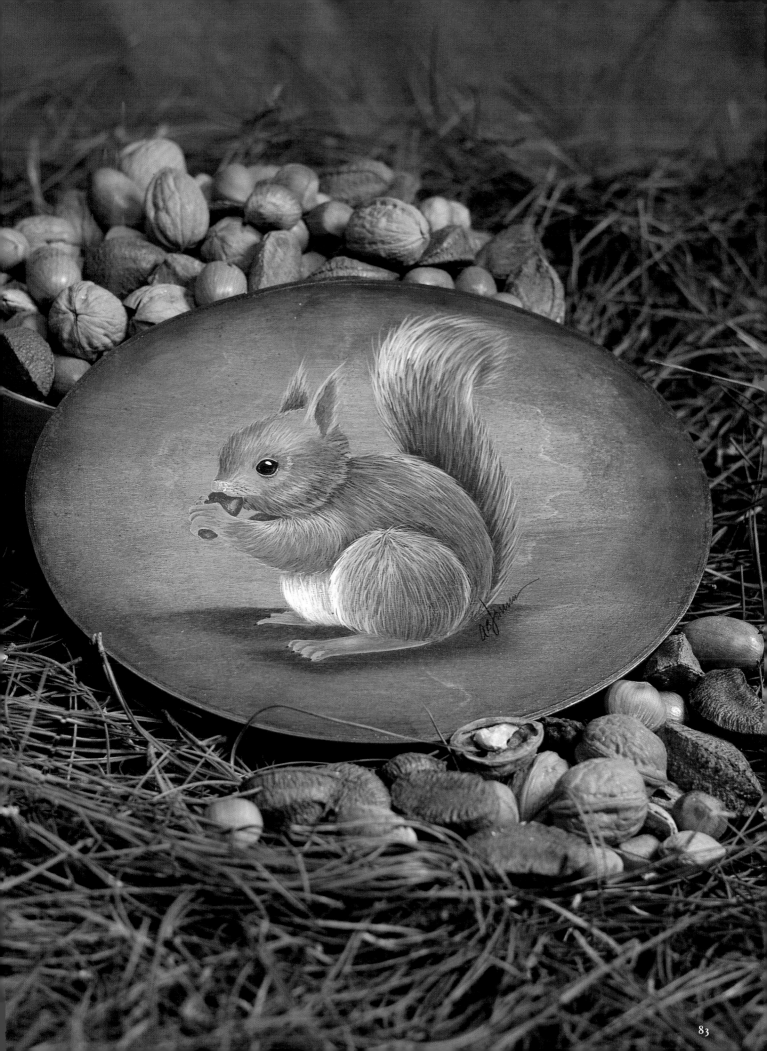

Squirrel

GETTING READY

Sand, tack, and stain the box according to the instructions on page 39. Work on the lid first. Apply the gel retarder and the asphaltum glaze, then wipe back the glaze with a cotton rag. Apply burnt umber around the edge of the lid, then blend the color in toward the center to create a smooth, dark-to-light gradation. Repeat this procedure on the bottom and sides of the box. Let dry overnight, then buff the entire box with a brown paper bag.

Following the instructions on page 43, flyspeck the edge of the lid with apple spice acrylic or latex paint. Let dry.

Trace the pattern, then transfer it to the lid. Do not transfer the shadow, which will be painted in the final step.

1 The squirrel pattern has four main sections: the head (including the ears), the body (including the foreleg), the tail, and the hind leg. (Note that the paws are painted separately in step 4.) In this step, you should work on only one section of the pattern at a time or the paint will dry before you have a chance to blend it.

Coat the section with a layer of gel retarder, then apply a light coat of asphaltum into the wet gel. While the surface is still wet, stroke one side of the brush into burnt umber, then apply the color to the shaded area of the section. Wipe the brush on a paper towel, then blend the burnt umber out into the section so that it fades gently into the asphaltum. Let dry. Repeat for the remaining sections.

2 Mix asphaltum + a tad of warm white to create a light brown, then thin it with water to a flowing consistency. Use the script liner to apply the squirrel's fur as individual hairs, stroking it on following the contours of, and the direction of fur growth in, each section. Cover each section completely with light brown hairs, then let dry. Lighten the mixture by adding more warm white, thin it as needed with water, then apply a second layer of fur, but only to the unshaded areas of each section. Let dry.

3 Continue building the highlights in each section by adding two more layers of fur, letting the first layer dry before applying the next. Lighten the paint each time by adding more warm white, and apply each layer to a smaller area.

Using warm white alone, establish the peaks of the highlights in just a few specific areas: at the tip of the tail, on the front of the hind leg, on the tummy, and on the muzzle and cheeks.

FINISHING

Apply two coats of
varnish to the box,
letting the first coat
dry before applying
the second.

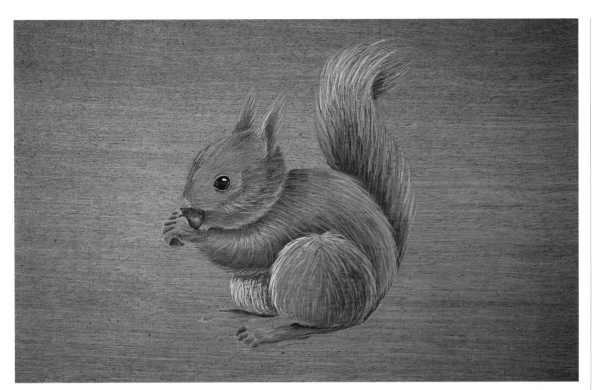

4 Use the script liner to paint the eye, and let each layer of paint dry before applying the next. Undercoat with pure black, then highlight the top right corner with a dot of titanium white. Use a dry brush to softly accent the circumference of the eye with ice blue.

Undercoat the paws with a mixture of asphaltum + warm white. Let dry, then use a little burnt umber to shade the wrist and legs and to establish the toes. Once the shading is dry, highlight each toe by lightening the brown of the undercoat (see step 2) with a little more warm white.

Undercoat the nut with burnt umber, let dry, then highlight it with a little warm white.

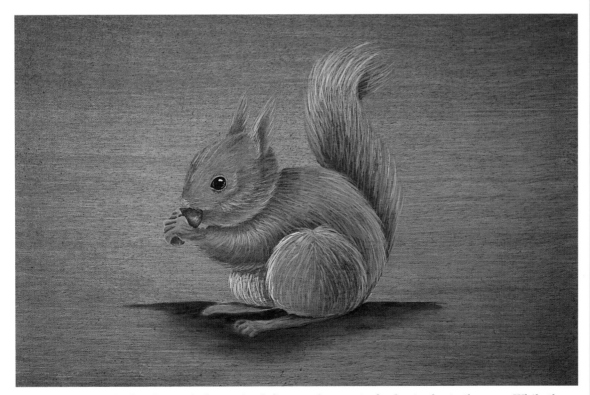

5 To create the shadow beneath the squirrel, first apply a coat of gel retarder to the area. While the gel is still wet, sideload the wash brush with burnt umber, then apply the paint beneath and between the hind paws. Wipe the brush on a paper towel, then soften the application by blending it away from the squirrel. Let dry.

Panda

Degree of
Difficulty

*T*he panda is one of the most instantly recognizable and beloved animals in the world. Sadly, it is also one of the most endangered. The destruction of the panda's habitat, the bamboo forests of China, has diminished its chances for survival, as its diet consists almost solely of bamboo shoots.

I love the Chinese folktale about how the panda got its distinctive markings: A shepherd girl died while saving a panda from a leopard attack. The pandas, which at that time were completely white, attended the girl's funeral wearing ashes on their shoulders, arms, and legs as a sign of mourning. As they cried and wiped their eyes and rested their heads in their paws, they smudged their faces with black. Since that day, all pandas have had beautiful black markings.

WHAT YOU'LL NEED

Pattern
Page 108

Project
Preprimed steel plate from
 Barb Watson's Brushworks
 *(see page 111 for ordering
 information)*

Supplies

SURFACE PREP
Paints for basecoating: kelly
 green *(strong, dark yellow-
 ish green acrylic or latex)*;
 sap green and pure black
 (see list of artists' acrylics)
Rubbing alcohol

TRACING AND
TRANSFERRING
Tracing paper
Fine-tip black marker
White transfer paper
Stylus

ARTISTS' ACRYLICS
Titanium white
Warm white
Yellow light
Ice blue
Burnt umber
Sap green
Hauser green medium
Green umber
Pure black

ACRYLIC MEDIUMS
Gel retarder

BRUSHES/APPLICATORS
Wash brush: ³/₄-inch
Glaze/varnish brushes::
 two 1-inch *(one for
 applying the glaze to the
 rim, one for varnishing)*
Old toothbrush
Flats: nos. 8 and 10
Script liner: no. 2
Old, worn round brush
 *(for stippling—don't use
 a new or good brush for
 this technique)*

BASIC PAINTING
SUPPLIES
Water container
Palette knife
Sta-Wet palette
Wax-coated paper palette
Paper towels

FINISHING
Brush-on satin-sheen
 acrylic varnish

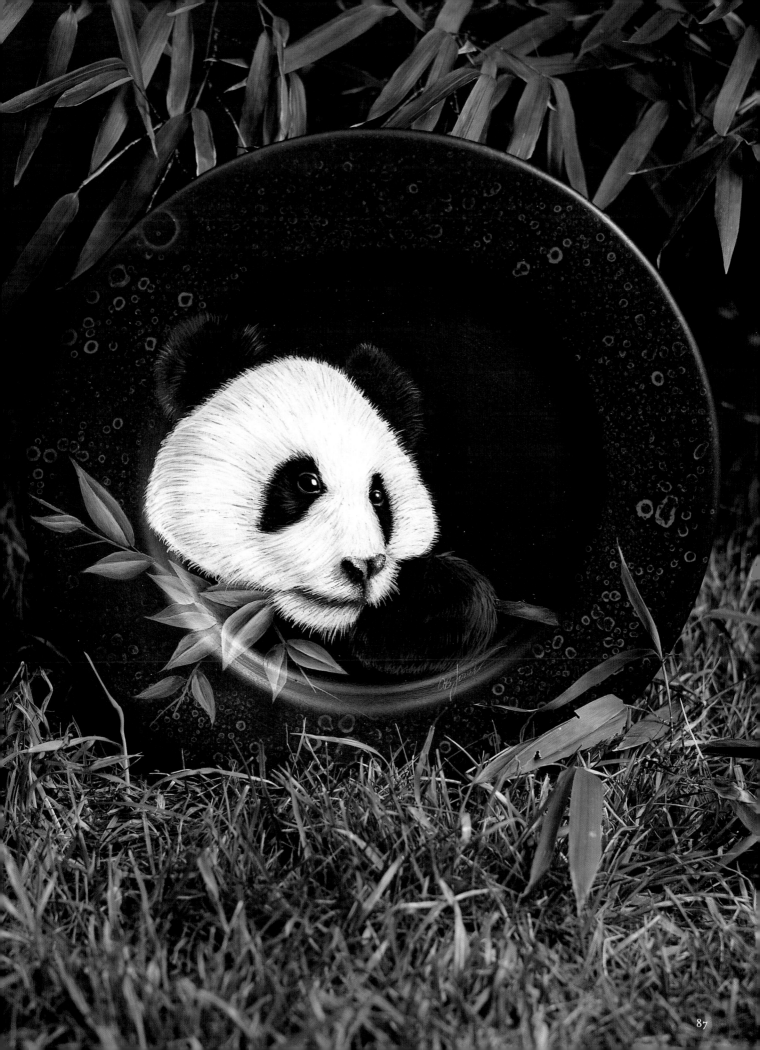

Panda

GETTING READY

Use the wash brush to basecoat the entire plate with kelly green. Let the first coat dry, then apply a second. Create a dark green by mixing sap green + a bit of pure black, then use it to paint the center of the plate. Let dry.

Combine equal parts gel retarder and the dark green mixture, then thin it with a little water to make it soupy. Apply this glaze to the rim of the plate with a glaze/varnish brush, then flyspeck it with rubbing alcohol while it is still wet. (See page 43 for specific instructions.)

Trace just the outlines of the pattern, omitting the details and shading within each area, then transfer the tracing to the surface when the rim is completely dry. You may need to snip the edges of the pattern so that it conforms to the plate's curves.

1 Using the largest flat brush that you can fit within a specific area, undercoat the pattern. For the panda's head, use warm white. Let dry, then undercoat the ears, eyes, eye patches, nose, and paw with pure black, leaving the transfer lines around the eyes, ears, and paw visible. If the first coat's coverage isn't opaque, apply a second, making sure that the first is completely dry. To create the lines beneath the nose and between the upper and lower jaws, use the no. 8 flat moistened with gel retarder, then sideloaded with a mixture of burnt umber + pure black.

Undercoat the base of the stem and the leaves with Hauser green medium.

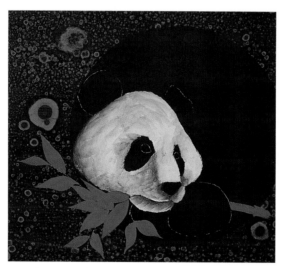

2 Thin two shading colors—burnt umber and burnt umber + pure black—with gel retarder until translucent. Using a flat brush, apply the darker mixture along the left side of the head, around the nose, and along the lower jaw. Let dry, then apply a light layer of thinned burnt umber to the rest of the head, stroking it so that it creates the face's curves and contours, which you'll use in the next step as a guide to painting the panda's fur. Apply the second color most intensely around the two eye patches.

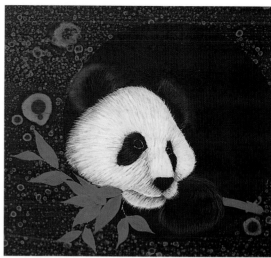

3 Load the script liner with warm white, then use it to paint individual hairs on the panda's face. Starting on the bridge of the nose between the eyes (the center point of the panda's face), paint short hairs in a downward direction. The longer hairs on either side of the nose, above the mouth line, and around the eye patches should follow the contours of the panda's face, while the hairs on the crest of the forehead should be long and straight. (Soften the boundaries between the eye patches and the face by starting a few of the surrounding hairs within the eye patches themselves.)

Use a mixture of ice blue + a little pure black thinned with water to highlight the edges of the ears, the lower portion of the eye patches, and selected areas of the paw with gently curving hairs.

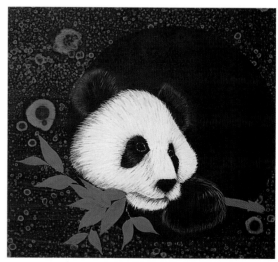

4 Highlight the panda's face with hairs of titanium white, concentrating on the bridge of the nose, the forehead, and the cheeks. You may need to apply two or three layers of hair to whiten the fur sufficiently.

Highlight the center of each ear, the right side of the paw, and the area just below the eye with hairs of ice blue.

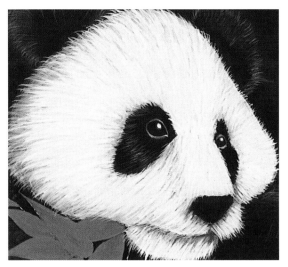

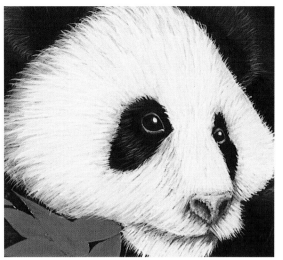

FINISHING

Finish the plate with two coats of varnish, letting the first coat dry before applying the second.

5 Use the script liner to paint the eyes, letting each application dry before applying the next. Undercoat the eyes with pure black. Outline them with a light gray mixture of pure black + a little ice blue, then highlight the outline with warm white + ice blue. Place a very thin line of titanium white along the inside edge of the bottom lid. Finish the eye with a titanium white highlight.

6 Undercoat the nose with the light gray that was used to outline the eyes in the preceding step. Let dry, then shade the nostrils with pure black. Stipple the edges of the nostrils with the gray of the undercoat. Lighten the gray with a little titanium white, then stipple it on the center of the nose.

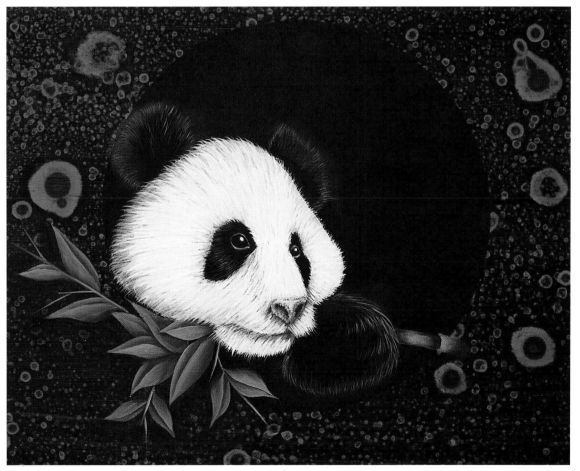

7 Shade the sections in the stem and the left side of each leaf with the no. 8 flat sideloaded with green umber. Let dry, then use the same brush to highlight the stem and the right side of each leaf with a sideload of Hauser green medium + yellow light + a bit of warm white. Paint the slender stems between the leaves with the script liner and Hauser green medium.

Rooster

**Degree of
Difficulty**

*P*oultry is more than just egg-laying hens and Thanksgiving turkeys. Many varieties of poultry are raised solely to meet a unique standard of beauty. The folk art rooster in this project, an amalgam of several breeds, embodies some of their best characteristics: big, beautiful tail feathers; bright, golden head and neck feathers; upright comb; and proud stance. I painted my barnyard beauty on copper tooling foil, which is sold in 12-inch-wide 10- and 25-inch rolls at most art supply stores. Because the tavern sign was too large to cover with a single sheet of foil, I overlapped several small pieces to create a patchwork effect, then treated the surface with a verdigris patina. For the sake of clarity, I painted the pattern on a single sheet of foil for the step-by-step demonstration.

WHAT YOU'LL NEED

Pattern
Page 109

Project/Surface
Copper tooling foil
22- x 31-inch tavern sign
 from The Cutting Edge
 *(see page 111 for ordering
 information)*

Supplies

SURFACE PREP/ASSEMBLY
For the copper: work gloves,
 scissors, contact cement OR
 hammer and nails, #0000
 steel wool, rubber gloves,
 patinizing solution *(such as
 Modern Options Patina
 Green),* and a sea sponge
For the frame: #220-grit sand-
 paper, tack cloth, and bright
 red acrylic or latex paint

**TRACING AND
TRANSFERRING**
Tracing paper
Fine-tip black marker
White and gray transfer paper
Stylus

ARTISTS' ACRYLICS
Titanium white
Yellow light
Medium yellow
Yellow ocher
Pure orange
Red light
Burnt sienna
Alizarin crimson
Dioxazine purple
Ice blue
Brilliant ultramarine
Prussian blue
Sap green
Hauser green light
Hauser green medium
Green umber
Burnt umber
Pure black

CRAFT ACRYLICS
Aqua *(light, bright
 blue-green)*

ACRYLIC MEDIUMS
Gel retarder
Glazing Medium

BRUSHES
Flats: nos. 4, 8, and 12
Script liner: no. 2
Filberts: nos. 6 and 10

**BASIC PAINTING
SUPPLIES**
Water container
Palette knife
Sta-Wet palette
Wax-coated paper palette
Paper towels

FINISHING
Two-part water-based
 crackle product
Brush-on satin-sheen
 acrylic varnish

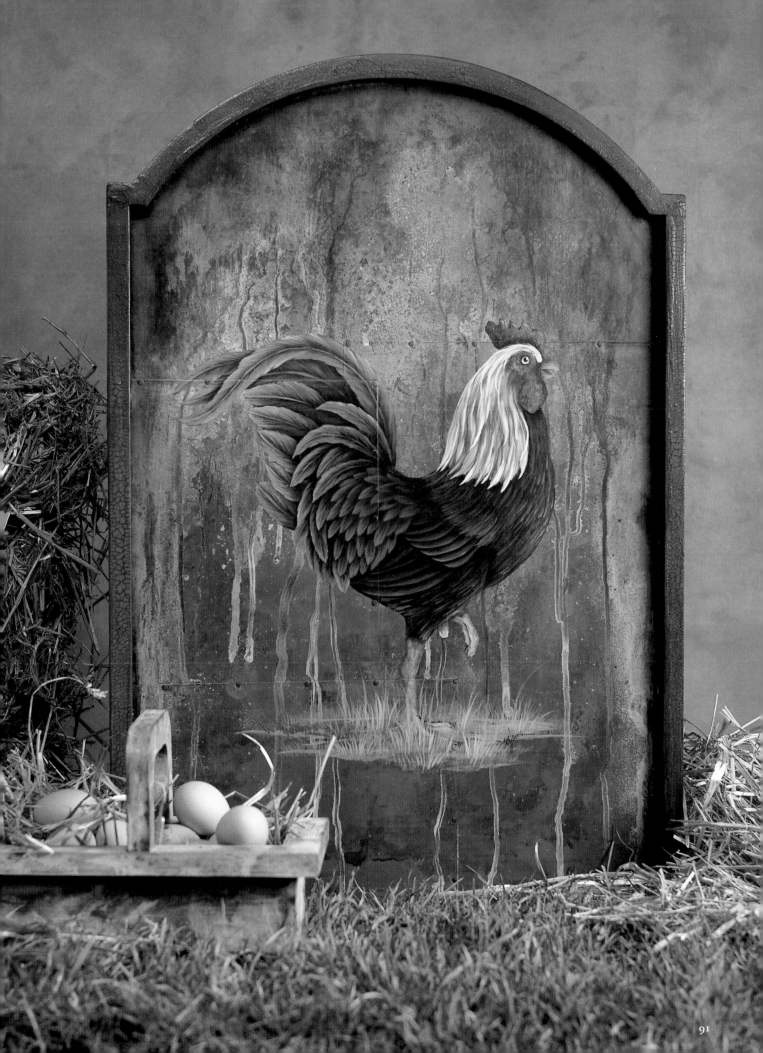

Rooster

GETTING READY

Wear work gloves when cutting the copper to protect your hands from sharp edges. (Note that the copper has a tendency to dent and wrinkle during handling.) Cut the copper into several pieces to fit snugly inside the frame of the tavern sign, then adhere them to the surface with contact cement following the manufacturer's instructions. (The pieces can also be affixed with nails; see the photograph on page 91 for an example.) Remove any fingerprints or greasy residue by vigorously burnishing the copper with steel wool.

I You must wear rubber gloves when applying the patina solution. Load the sea sponge with some solution, then dab it on the copper. I applied the solution at the top and allowed it to randomly drip down the surface in order to preserve some of the copper's natural color. The verdigris finish will begin to appear within a few hours. Let the copper dry overnight, then seal it with a coat of varnish. Let dry.

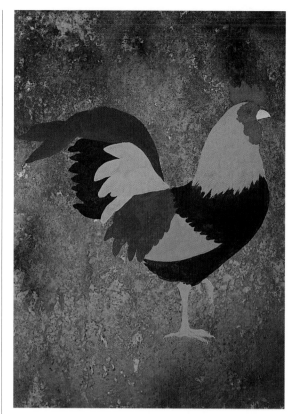

2 Trace the pattern, then transfer it to the surface. Because the surface is so varied in color and texture, you will need to use white as well as gray transfer paper in order to get a clear transfer. Undercoat each part of the rooster using the largest flat brush that you can comfortably maneuver within a given area.

- *For the comb, wattle, and eye area,* use red light.
- *For the beak and legs,* use medium yellow.
- *For the head and neck,* use yellow ocher.
- *For the body,* use burnt umber.
- *For the wing,* use burnt umber + titanium white.
- *For the saddle feathers,* use burnt sienna.
- *For the short tail feathers,* use ice blue.
- *For the rear tail feathers,* use Prussian blue.
- *For the long tail feathers,* use sap green + green umber + aqua.

Let the undercoat dry completely before proceeding to the next step.

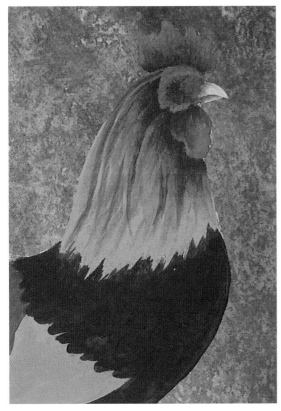

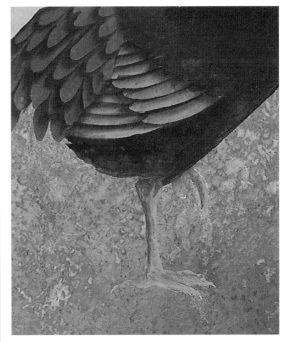

3 In this step and the two following, shade each part of the rooster with a sideloaded flat brush, using the largest flat brush that you can within each part. When more than one color is noted, apply the first color, let it dry, then intensify selected areas with the second color.

- *For the comb, wattle, and eye area,* use alizarin crimson, then alizarin crimson + green umber.
- *For the beak,* use burnt sienna.
- *For the head and neck,* use burnt sienna, then burnt umber.

4 Following the instructions outlined in the preceding step, continue shading the rooster with a sideloaded flat brush:

- *For the body,* use pure black.
- *For the wing,* use burnt umber, then pure black.
- *For the saddle feathers,* use burnt umber.
- *For the legs,* use burnt sienna, then burnt umber.

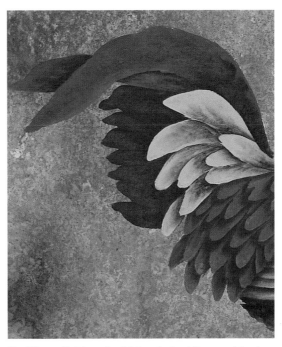

5 Use a flat brush sideloaded with pure black to complete the shading on the rooster's short, rear, and long tail feathers.

Make sure that all of the shading is dry before proceeding to the next step.

Rooster

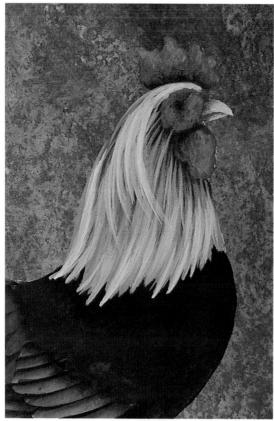

6 When applying highlights, work on one area at a time, and brush on a generous coat of gel retarder before applying any color. Make sure that the surface is wet the entire time you're working on it. When more than one color is called for, apply them in rapid succession, working from dark to light.

- *For the comb, wattle, and eye area,* use the no. 4 flat to dab on some red light, then red light + pure orange, then finally red light + pure orange + titanium white.
- *For the beak,* use medium yellow, then medium yellow + titanium white.
- *For the head and neck,* use the no. 10 filbert and the following sequence of colors: yellow ocher, medium yellow, light yellow, and light yellow + titanium white.

7 Again coating each section with retarder, apply highlights to the tail feathers as follows:

- *For the short tail feathers,* apply ice blue with the no. 6 filbert.
- *For the rear tail feathers,* use the no. 10 filbert to apply brilliant ultramarine, then brilliant ultramarine + ice blue.
- *For the long tail feathers,* use the no. 10 filbert to stroke on the green of the undercoat (see step 2) + aqua, then the same mixture lightened with titanium white.

8 Complete the highlights on the saddle feathers, body, wing, and legs.

- *For the saddle feathers,* apply yellow ocher, then yellow ocher + medium yellow, with the script liner.
- *For the body,* use the no. 10 filbert brush to apply a thin coat of burnt umber, then quickly shade it with pure black. While the surface is still wet, make short strokes of ice blue, aqua, and aqua + medium yellow, which will make the feathers look iridescent.
- *For the wing,* use burnt umber + titanium white and the no. 8 flat.
- *For the legs,* use the no. 4 flat to apply medium yellow, then medium yellow + light yellow.

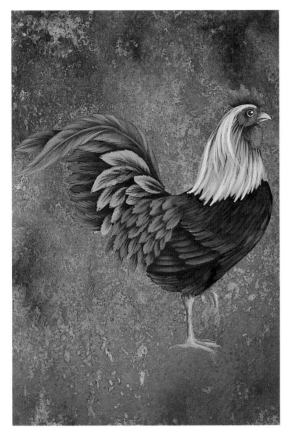

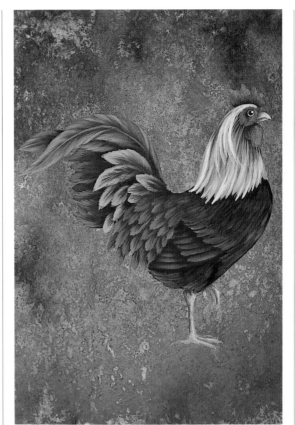

9 Use the script liner to paint the rooster's eye. Begin by undercoating with yellow ocher. While the paint is still wet, shade the top half with burnt sienna and highlight the bottom half with light yellow. Let dry. Paint the pupil with pure black. Once the pupil is dry, dab a highlight of titanium white on its upper righthand quarter.

10 Use either the no. 8 or the no. 12 flat to apply colorful washes to increase the visual interest in some sections of the feathers.

- *On the neck and saddle feathers,* use an alizarin crimson wash.
- *On the short tail feathers,* apply a wash of burnt sienna.
- *On the rear tail feathers,* use a dioxazine purple wash.

11 To begin the patch of grass, use the no. 12 flat to dab some green umber beneath and around the rooster's foot, then dab Hauser green medium over and around it. Let dry. Use the script liner to paint some blades of grass, some arranged in tufts, using Hauser green medium and Hauser green light thinned with water.

Giraffe

The reticulated giraffe is one of the most graceful animals on the African plain. In addition to its height and extremely long neck, the giraffe's most conspicuous feature is its spotted coat. Much like a human fingerprint, the spot pattern of each giraffe is unique and can be used to identify an individual. For this project, I painted a young giraffe on a stained wooden panel, then stained and stenciled the panel's frame with a giraffe skin pattern.

WHAT YOU'LL NEED

Pattern
Page 110

Project
Wooden panel *(available at most home improvement stores)*
Wooden frame *(available at many custom framing shops)*

Supplies

SURFACE PREP
#220-grit sandpaper
Tack cloth
Paints for staining: warm white and Turner's yellow *(see list of artists' acrylics)*
Brown grocery bag
Cotton cloth

TRACING AND TRANSFERRING
Tracing paper
Fine-tip black marker
White and gray transfer paper
Stylus

ARTISTS' ACRYLICS
Titanium white
Warm white
Yellow light
Medium yellow
Turner's yellow
Yellow ocher
Pure orange
Ice blue
Asphaltum
Burnt sienna
Burnt umber
Pure black

ACRYLIC MEDIUMS
Gel retarder
Glazing Medium

BRUSHES
Glaze/varnish brushes: two 1-inch *(one for staining, one for varnishing)*
Flats: nos. 4, 10, and 12
Filbert: no. 6
Wash brush: ³/₄-inch
Script liner: no. 2
Stencil brush *(optional):* no. 14

BASIC PAINTING SUPPLIES
Palette knife
Water container
Wax-coated paper palette
Sta-Wet palette
Paper towels

SPECIAL PROJECT SUPPLIES
Optional: "Skinz" stencil #28915 from PCM Studios *(see page 111 for ordering information)*
Soft cotton cloth

FINISHING
Brush-on satin-sheen acrylic varnish

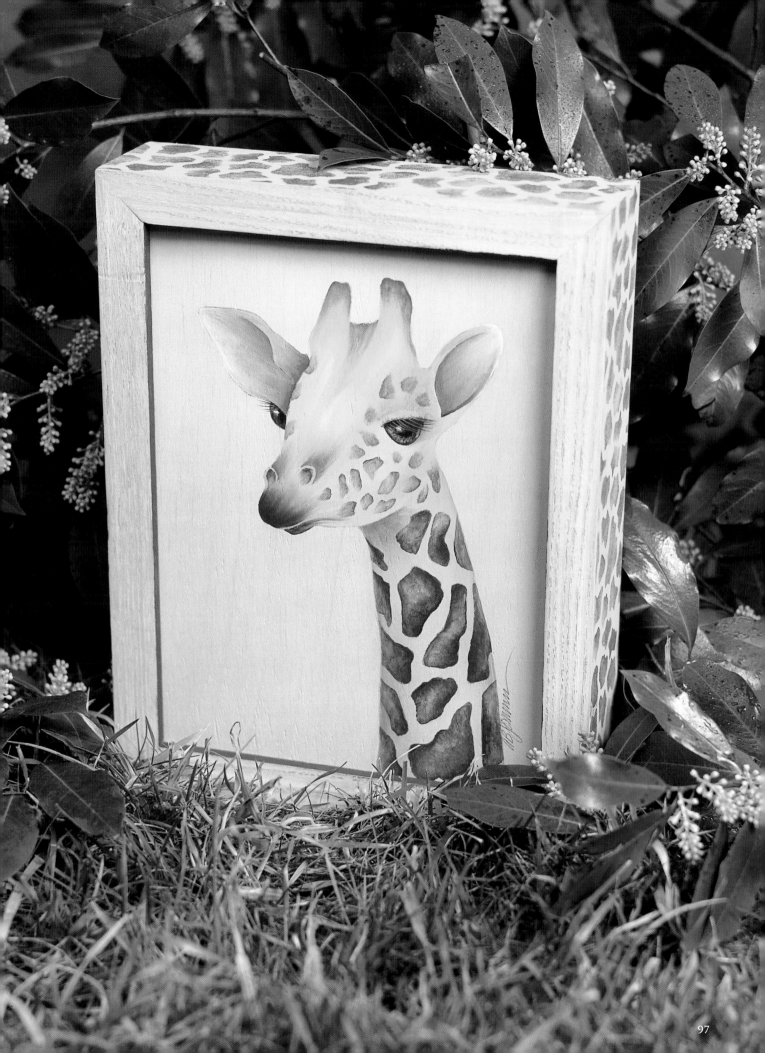

Giraffe

GETTING READY

Sand, tack, and stain the panel according to the instructions on page 39. Apply the gel retarder and a warm white glaze, then apply a little Turner's yellow to the lower right-hand corner with a glaze/varnish brush. Wipe the brush on a paper towel, then use it to blend the yellow into the white glaze to create a soft shadow effect. Wipe back the stain with a cotton rag, let dry, then buff with a brown paper bag.

Trace the pattern, then transfer the giraffe's outlines only according to the instructions on page 41. Don't transfer the spots or any other details at this time.

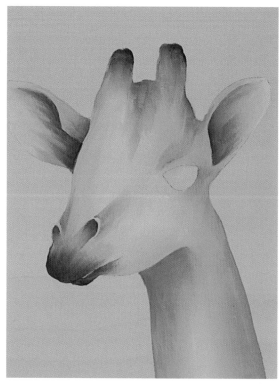

I Use the no. 12 flat brush to apply a thin coat of blending gel to the neck. Wipe the brush on a paper towel, then apply a vertical stripe of titanium white down the center. On either side of the white, apply a stripe of yellow light, then apply a stripe of medium yellow next to each stripe of yellow light. Finally, apply yellow ocher along the sides of the neck. Wipe the brush again, then use it to blend and soften the areas where two colors meet. The retarder should keep the paint wet and workable as you blend it.

When you're done, blend a bit of pure orange along the lower lefthand side of the neck. Let dry. Apply some burnt sienna + a touch of yellow ocher beneath the chin, then soften the edges of the application.

2 Use the no. 10 or 12 flat for this step. Apply a thin coat of gel retarder to the giraffe's head. Stroke titanium white along the bridge of the nose and the cheek. Surround the white areas first with yellow light, then with medium yellow. Apply yellow ocher to the rest of the head. Wipe the brush, then use it to soften the areas where two colors meet. Use burnt sienna to shade the tips of the horns, the muzzle, and around the ears, as well as to paint the nostrils. Soften the application by gently drawing it into the yellow areas. Intensify the shading on the tips of the horns and the mouth with a little burnt umber.

Coat both ears with gel retarder, then apply the following colors, working from the outside edge of each ear inward: titanium white, yellow light, medium yellow, and yellow ocher. Wipe the brush, then gently blend. Shape the inside of the ear by applying burnt sienna + burnt umber to the base of the curve, then blending it out into the ear. Let dry.

3 Work on the eyes simultaneously. Apply a thin layer of retarder, then stroke a very thin layer of asphaltum into the wet gel so that the color is completely translucent. Shade the top of the eye with burnt umber, then blend it into the asphaltum. Use the script liner to apply short vertical strokes of yellow ocher in a crescent shape in the lower portion of the eye; these will blur into the wet asphaltum. On the far right edge of the right eye, paint a thin reflected light of ice blue. Create the pupil by painting dots of pure black in the eye's center. Let dry.

Thin ice blue + titanium white with water until it is translucent. Use the script liner to dab a highlight on the eye. Rinse the brush, load it with titanium white, then apply a strong glint in the center of the highlight. Let dry before proceeding.

Use the script liner to paint the eyelashes with burnt umber thinned with water. Accent the lashes that fall across the eye with thinned ice blue. Let dry.

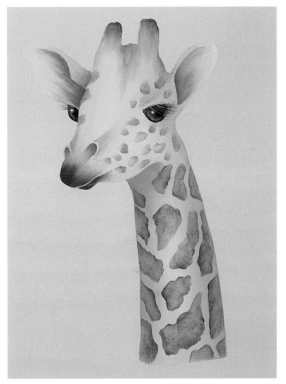

4 Transfer the outlines of the spots to the giraffe. Thin some asphaltum with a little retarder, then use the no. 4 flat to paint the spots with loose strokes, to create a slight texture. Let dry.

FINISHING

Finish the panel with two coats of varnish, letting the first coat dry before applying the second one. Set aside. Stain the frame with warm white. Once the surface is dry, paint the outside edges with Turner's yellow; let dry. If desired, you may stencil the edges with giraffe spots using a mixture of asphaltum + a little burnt umber. Let dry, then finish the frame with two coats of varnish. Insert the panel into the frame.

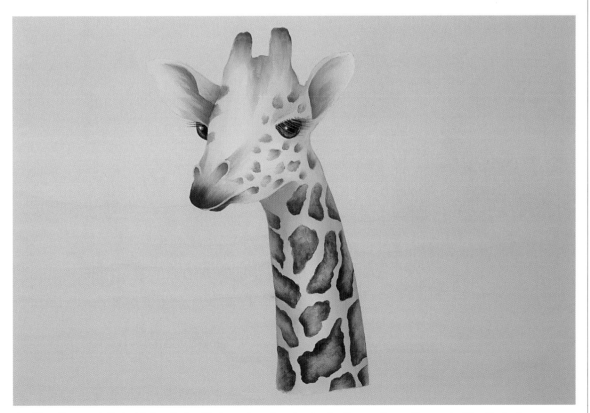

5 Use the no. 4 flat sideloaded with burnt umber to shade the spots on the neck. Don't shade every spot in the same way; there should be some variety among them. Allow the painting to dry completely.

Patterns

BUNNIES

Project instructions are on pages 50–53. Use the tracing at same size. See pages 40–41 for detailed instructions on tracing and transferring patterns.

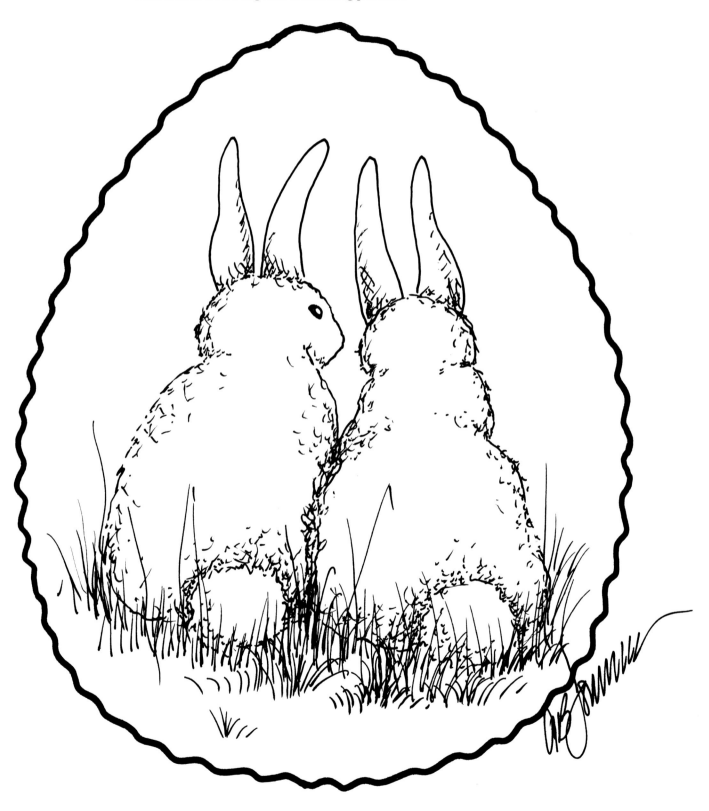

HEN

Project instructions are on pages 54–57. Enlarge the tracing at 143%. See pages 40–41 for detailed instructions on tracing, sizing, and transferring patterns.

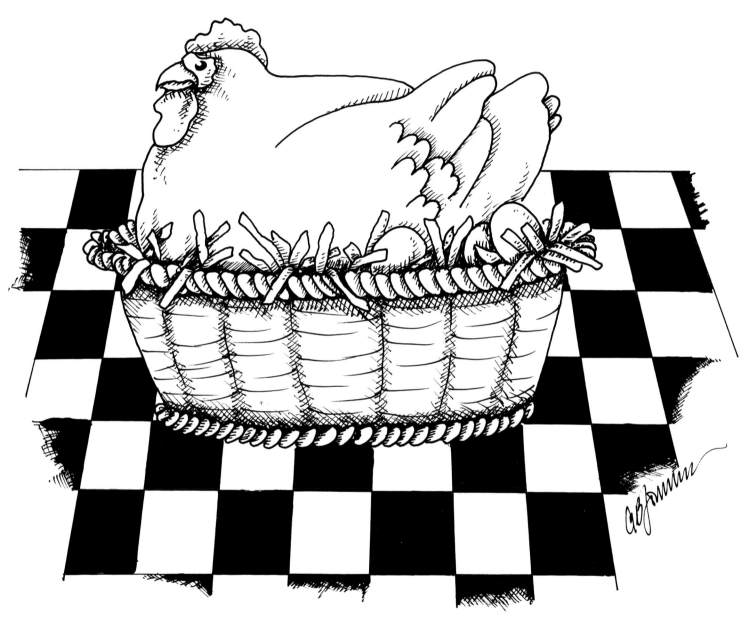

DOG

Project instructions are on pages 58–61. Use the tracings at same size. See pages 40–41 for detailed instructions on tracing and transferring patterns.

TREATS

FISH

Project instructions are on pages 62–65. Use the tracing at same size. See pages 40–41 for detailed instructions on tracing and transferring patterns.

CAT

Project instructions are on pages 66–69. Use the tracings at same size. See pages 40–41 for detailed instructions on tracing and transferring patterns.

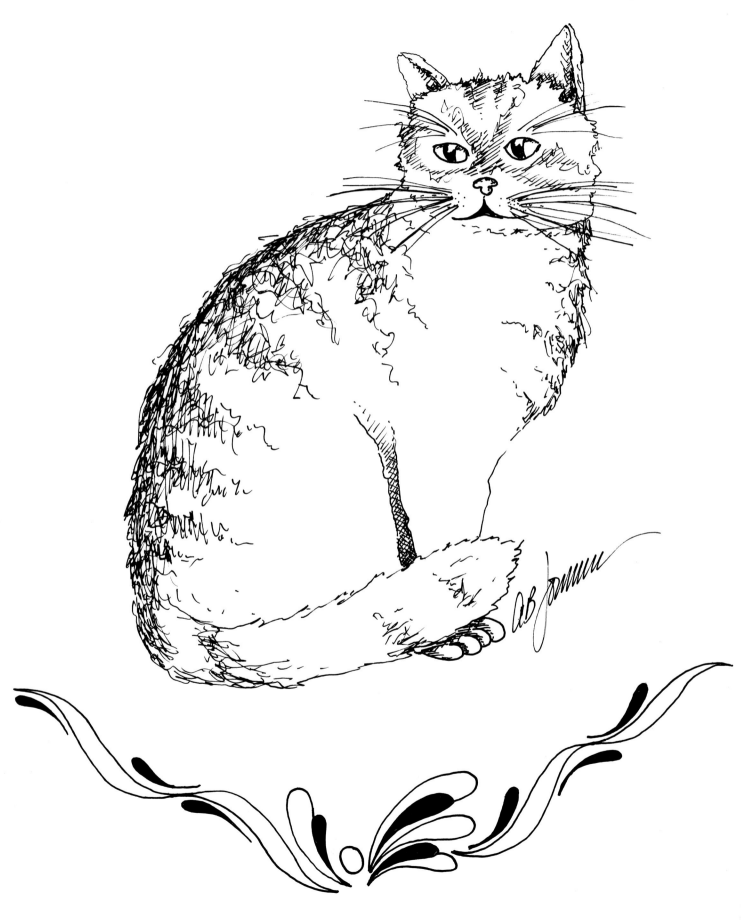

PIGS

Project instructions are on pages 70–73. Enlarge the tracing at 143%. See pages 40–41 for detailed instructions on tracing, sizing, and transferring patterns.

STROKE DESIGN FOR THE RIGHT SIDE OF THE RECIPE BOX (FLOP THE TRACING FOR THE LEFT SIDE)

STROKE DESIGN FOR THE DRAWER FRONT

HORSE

Project instructions are on pages 74–77. Enlarge the tracing at 143%. See pages 40–41 for detailed instructions on tracing, sizing, and transferring patterns.

SQUIRREL

Project instructions are on pages 82–85. Enlarge the tracing at 143%. See pages 40–41 for detailed instructions on tracing, sizing, and transferring patterns.

COW AND CALF

Project instructions are on pages 78–81. Enlarge the tracing at 133%. See pages 40–41 for detailed instructions on tracing, sizing, and transferring patterns.

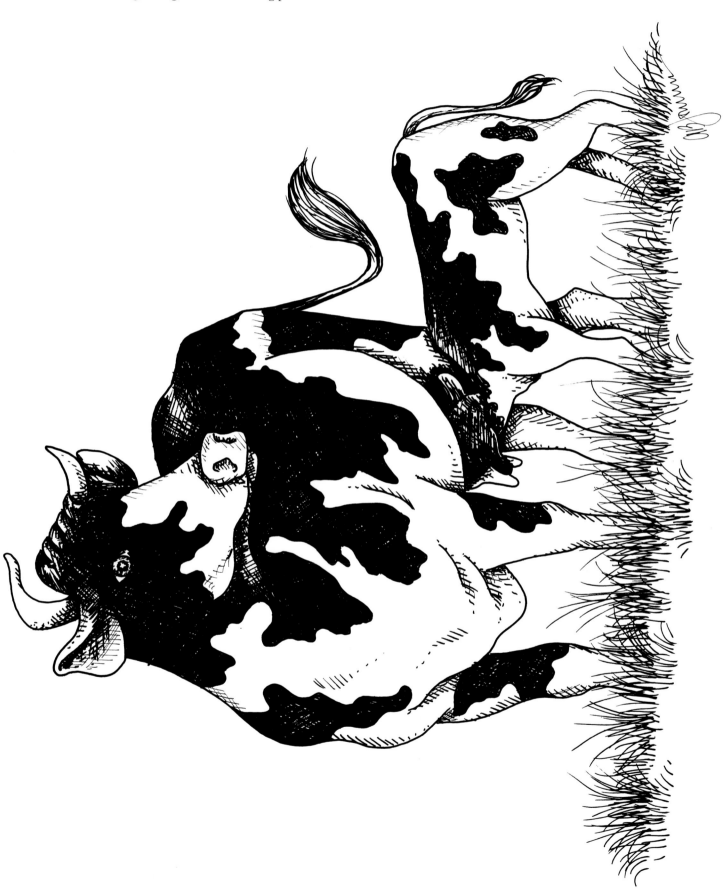

PANDA

Project instructions are on pages 86–89. Use the tracing at same size. See pages 40–41 for detailed instructions on tracing and transferring patterns.

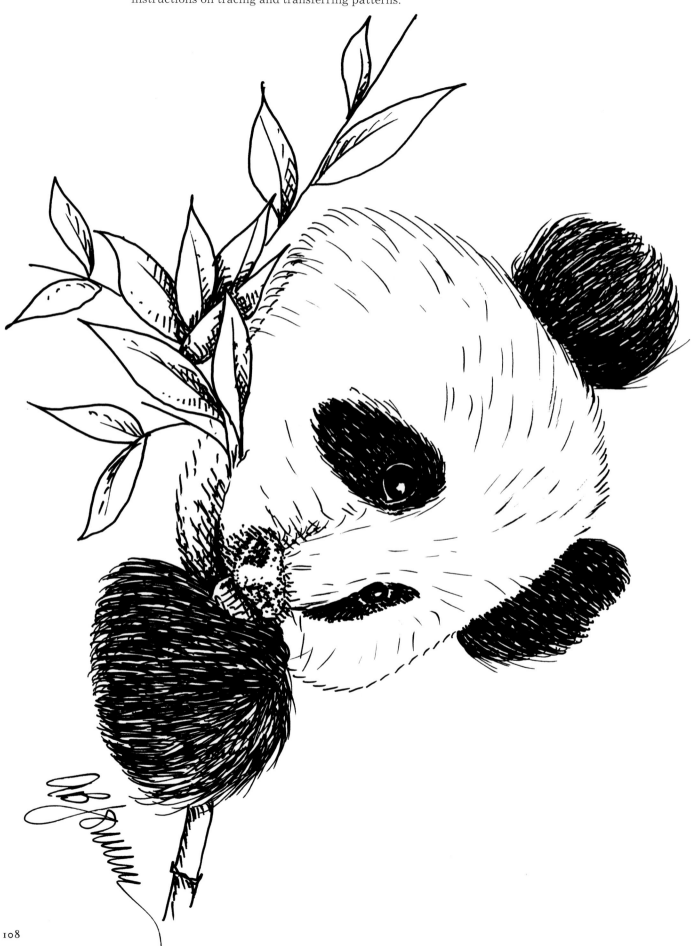

ROOSTER

Project instructions are on pages 90–95. Enlarge the tracing at 133%. See pages 40–41 for detailed instructions on tracing, sizing, and transferring patterns.

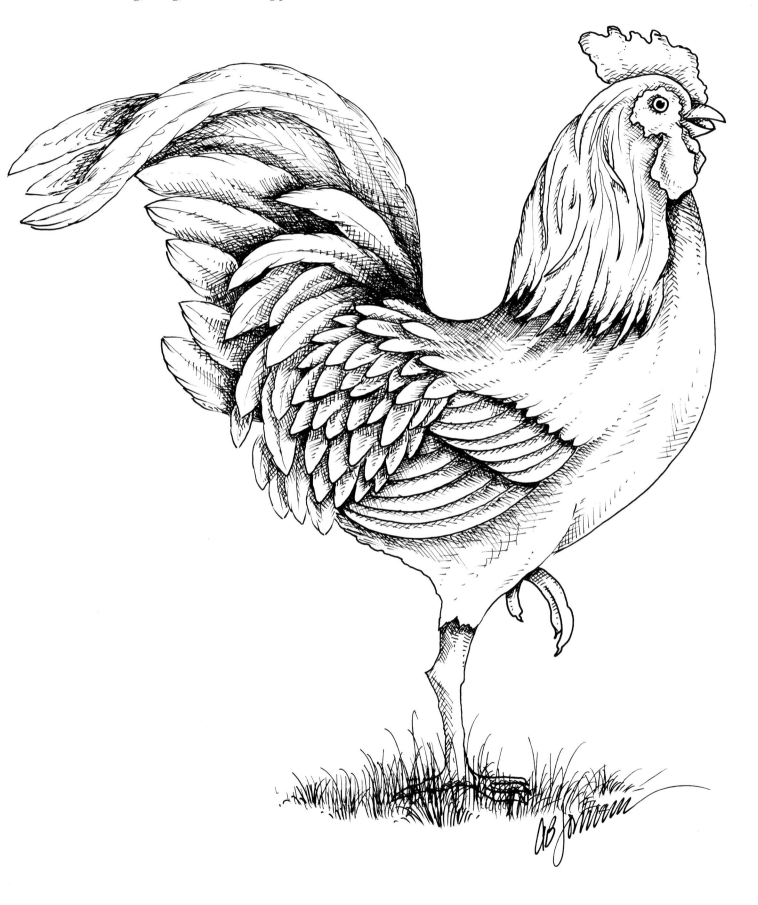

GIRAFFE

Project instructions are on pages 96–99. Use the tracing at same size. See pages 40–41 for detailed instructions on tracing and transferring patterns.

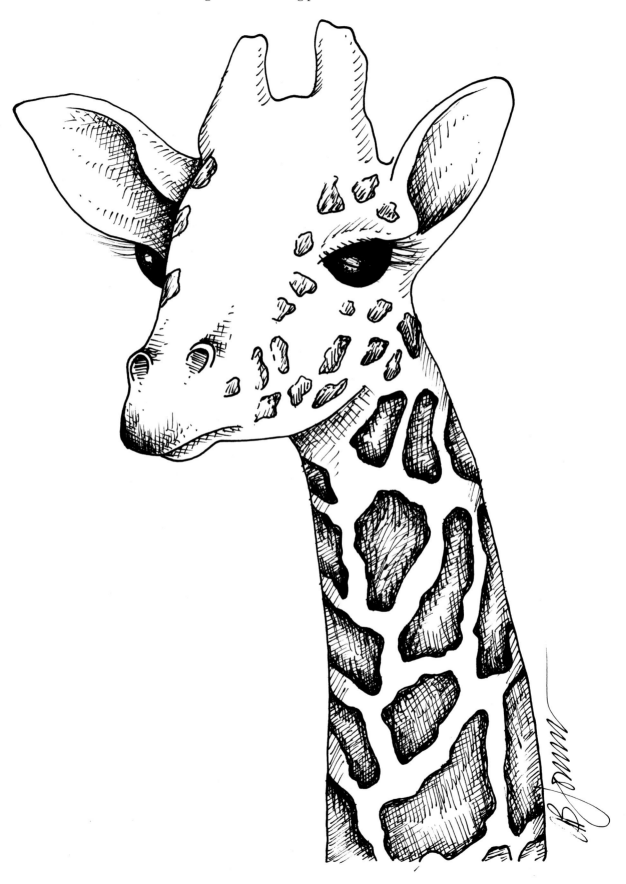

Source Directory

The following is a list of sources for the supplies and projects that are used in this book. The supplies can be purchased at most art supply and craft stores nationwide. If you're interested in purchasing any of the projects, simply contact the company at the address listed below. Note that many of the project manufacturers will send catalogs of their product lines upon request.

SUPPLIES

PLAID ENTERPRISES
1649 International Court
Norcross, Georgia 30093
Acrylic paints and other decorative painting materials and supplies

SILVER BRUSH LIMITED
P.O. Box 414
Windsor, New Jersey 08561
Artist-quality brushes for decorative painting, stenciling, and faux finishing

PROJECTS

BARB WATSON'S BRUSHWORKS
P.O. Box 1467
Moreno Valley, California 92556
(909) 653-3780
http://www.barbwatson.com/
Panda project: preprimed steel plate (see pages 86–89)

BUSH'S SMOKY MOUNTAIN WOOD PRODUCTS
3556 Wilhite Road
Severille, Tennessee 37876
(423) 453-4829
Horse project: wooden box (see pages 74–77)

CLOVER MANUFACTURING
3-15-5 Nakamichi
Higashinari-ku
Osaka 537-0025
Japan
(06) 978-2213
Hen project: cutting board (see pages 54–57)

THE CUTTING EDGE
P.O. Box 3000-402
Chino, California 91708
(909) 464-0440
Pigs project: recipe box (pages 70–73)
Rooster project: 22- × 31-inch tavern sign (see pages 90–93)

GRETCHEN CAGLE PUBLICATIONS
P.O. Box 2104
Claremore, Oklahoma 74018
(918) 342-6188
Fish project: wooden plaque (see pages 62–65)

PCM STUDIOS
731 Highland Avenue N.E. - Suite D
Atlanta, Georgia 30312
(404) 222-0348
Dog project: tea chest/treat box (see pages 58–61)
Giraffe project: "Skinz" stencil #28915 (see pages 96–99)

PESKY BEAR
5059 Roszyk Road
Machias, New York 14101
(716) 942-3250
Cow and Calf project: picnic basket (see pages 78–81)
Squirrel project: oval Shaker box (see pages 82–85

ROBINSON'S WOODS
1057 Trumbull Avenue - Unit N
Girard, Ohio 44420
(330) 759-3843
Bunnies project: wooden egg (see pages 50–53)

ST. LOUIS CRAFTS
7606 Idaho Avenue
St. Louis, Missouri 63111-3219
(314) 638-0038
Rooster project: copper tooling foil (see pages 90–93)

WAYNE'S WOODENWARE
1913 State Road 150
Neenah, Wisconsin 54956
(800) 840-1497
Cat project: wooden plate (see pages 66–69)

Index